MICHELLE TURNER
THE WEDDING PHOTOGRAPHY FIELD GUIDE

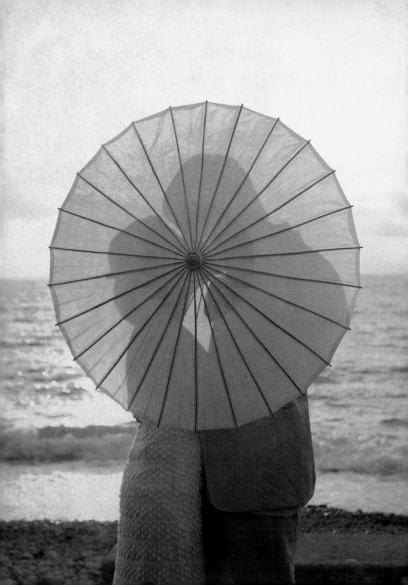

MICHELLE TURNER
THE WEDDING PHOTOGRAPHY FIELD GUIDE

Capturing the **perfect day** with your digital SLR camera

AMSTERDAM • BOSTON • HEIDELBERG • LONDON
NEW YORK • OXFORD • PARIS • SAN DIEGO
SAN FRANCISCO • SINGAPORE • SYDNEY • TOKYO

Focal Press is an imprint of Elsevier

ELSEVIER

Focal Press

Focal Press is an imprint of Elsevier

30 Corporate Drive, Suite 400, Burlington,
MA 01803, USA

This book was conceived, designed,
and produced by Ilex Press Limited
210 High Street, Lewes, BN7 2NS, UK

Publisher: Alastair Campbell
Creative Director: Peter Bridgewater
Associate Publisher: Adam Juniper
Managing Editor: Natalia Price-Cabrera
Editorial Assistant: Tara Gallagher
Art Director: James Hollywell
Designer: Jon Allan, TwoSheds Design
Color Origination: Ivy Press Reprographics

Library of Congress Control Number
A catalog record for this book is available from the
Library of Congress.

ISBN: 978-0-240-81787-3

For information on all Focal Press publications visit our
website at: www.focalpress.com

Printed and bound in China

10 11 12 13 14 5 4 3 2 1

CONTENTS

INTRODUCTION

Photographing a wedding is a rewarding experience. It is a joyous occasion, full of touching moments, beautiful details, and a couple decked out in their finest. It can also be a stressful experience if you don't know what to expect. Whether you make wedding photography your hobby or your career, weddings are once-in-a-lifetime events and you need to be prepared to cover them to the best of your ability.

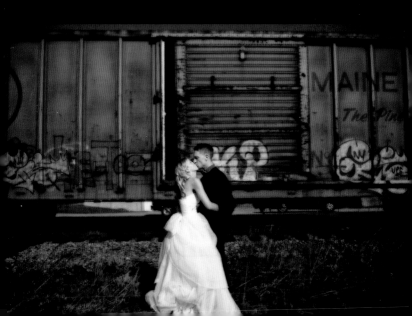

The world of wedding photography is changing. Gone are the days of the cookie-cutter approach; increasingly couples are looking for a creative wedding photography that will capture the essence of who they are as a couple. Often they want photographs of the two of them interacting with one another and being spontaneous rather than just another photograph of them looking straight at the camera. Many couples want a dual approach—documentary wedding photography combined with interesting portraiture—and they are willing to give their photographer total creative license to achieve something unique.

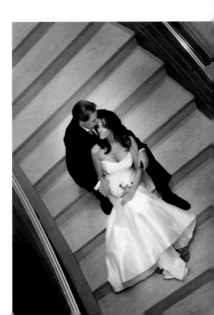

LEFT Take your couple into different environments for a trendy "urban grunge" look. Keep an eye out for well-drawn or at least suitably colored graffiti (and remember, you can always airbrush out the odd tag).

RIGHT A modern couple in a classic environment. Even in the most traditional of settings it's possible to find new and interesting angles.

GEAR

Technology is ever-changing, and as a photographer it can be a daunting task to navigate the jungle of gear on the market from year to year. It seems that every time you turn around a new camera body, computer, or lens is being announced. With new cameras and technology constantly being developed, it is sometimes difficult to know where to start.

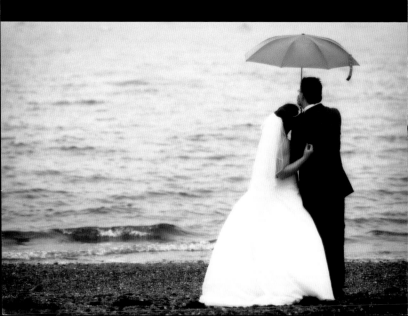

There is no right or wrong kit to buy—Nikon vs Canon, prime lenses vs zoom lenses, Mac vs PC—at the end of the day the only thing that is important is that you buy a system that works for you. You need to have a system that will help you produce the photographs that you want to produce. Your camera, your lenses and your computers are only the tools with which you can realize your artistic vision. Simply having the most expensive tools available will not make you a fabulous photographer—the camera will only be as good as the person using it. There are many professional photographers out there who could take award-winning photographs using just a disposable camera.

Before you go out and buy a new kit, it is important to assess your needs. First and foremost, know what your budget is. Keep in mind that it is important to have a backup camera (even two backups) at each and every wedding that you photograph if you are going to be the primary photographer. While the backup does not need to be the same model as your primary camera (and many photographers do spend less money on their backup equipment), you need to be sure that you would be comfortable shooting the entire event on your backup camera. There are no do-overs in wedding photography, and you need to make sure that you have adequate backup in case of an accident (I have had a camera smashed out of my hands on the dance floor before) or equipment failure (I once had a camera fail early in the day, when the bride was putting on her dress). You should also have backups for everything else—your most-used lens, your flash and extra-memory cards. Whether photography is a hobby or a profession for you, it is going to get expensive, so know what you can spend up-front.

LEFT Regardless of the weather, you can capture memorable and intimate shots of the couple. Just make sure you have the right kit and you are ready for all eventualities. Creativity is often key, as is an eye for the unusual.

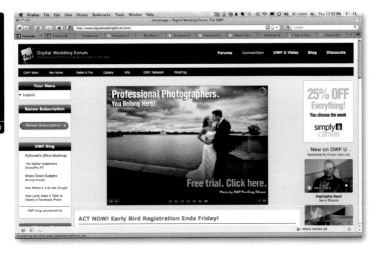

In the following chapters I will talk about the different products available. It is important, however, that you go to camera and computer stores and try the products out for yourself. Find the gear that you are comfortable with. Find the camera system that is easy for you to understand and the computer system that you find to be the most intuitive. If possible, rent or borrow a few different systems and test them out in real-world situations before you spend a lot of money.

Read reviews on products before you buy, but remember to take them with a grain of salt. Some of the reviewers are sponsored by the camera companies, so make sure that you read reviews from a variety of sources. Talk to the professionals that use the camera systems and look at images from each camera. Fortunately, there are several sites that are available to help you make an informed decision about your purchase. First, my most valuable online resource has been the *Digital Wedding Forum* (http://www.digitalweddingforum.com).

I will mention this resource again later, but suffice to say that the *DWF* is made up of thousands of working professionals and has a forum that is dedicated to gear. Another great resource can be found at *DPReview* (http://www.dpreview.com). They review all new cameras and have sample photographs from each camera available in Raw and jpeg. Fred Miranda's website (http://www.fredmiranda.com) and *Luminous Landscape* (http://www.luminous-landscape.com) are also great websites to peruse if you are in the market for a new camera or lens. If you are looking for Nikon lenses, I have found Bjørn Rørslett's website (http://www.naturfotograf.com) to be a great place to start.

There are four essentials for photographers in the digital age: the camera bodies; the lenses; the computers and the software. There are also many extras that are available: on-camera flashes; off-camera strobes; specialty lights and specialty cameras. The sheer volume of equipment available can be a bit daunting—hopefully the next few chapters will help you navigate the world of photography equipment.

USEFUL WEBSITES

OPPOSITE *Digital Wedding Forum* is a valuable online resource, made up of thousands of working professionals. It also has a useful forum dedicated to gear.

ABOVE *DPReview* reviews all the cameras on the market. It also shows sample photographs from each camera, available in Raw and jpeg.

Cameras

Unless you photograph with a film camera, it can be incredibly difficult to keep up with the ever-changing camera models. Nikon and Canon announce new camera models every year, and the ever-expanding line of cameras has blurred the distinction between professional, prosumer and consumer models.

The two big players in the DSLR market right now are Nikon and Canon. I personally shoot Nikon and have done so since the beginning of my career, but I have assistants who shoot Canon and I have worked with the files enough to say that the files coming out of the top-of-the-line cameras from both companies are simply incredible. With updates to the professional, prosumer and consumer DSLRs coming every year, the cameras and the files that they output are just getting better and better. I now regularly photograph at an ISO of 6400 during certain parts of my reception (I shoot with the Nikon D3S), and the lack of digital noise in a well-exposed file from the D3S at 6400 is astonishing.

When you are choosing a camera, it is important to know whether the body has a cropped sensor or whether it is full-frame. You may have a preference—for example, I prefer shooting full-frame and the latest Nikon top-of-the-line DSLRs have all been full-frame. However, there are several Canon and Nikon DSLRs that have cropped sensors, and I know that some professionals prefer them because the cropped sensor will give them the extra reach from their lenses. For example, the maximum reach of the 70–200mm on a 1.5x crop factor will be

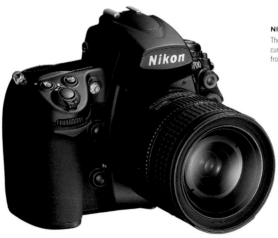

NIKON D3S
The Nikon D3S—the most current professional DSLR from Nikon.

300mm instead of 200mm. So, if you routinely photograph large weddings (or you photograph wildlife), you may prefer a cropped sensor. Price may also be a factor in your choice—on the Nikon side of the equation, the full-frame cameras are the most expensive by far.

It is also important to look at some of the other specs on the camera before you purchase anything—for example, what is the maximum ISO? Does your camera have dual card slots? Does it allow you to shoot video? The model of camera that you prefer may be dictated by your answer to those questions. I like shooting at high ISOs with available light, and I like shooting dual-card slots (I shoot one card of Raw files on one card and shoot jpegs of the same images simultaneously on the second card), and I need a rugged camera

body since I do a lot of sessions outdoors in the wind on the beach, so the Nikon D3S (and the Nikon D3 before it) was the camera body that I needed. You may find that your needs are different, so do your research (check out some of the reviews and sample images at places like dpreview.com and some of the photo magazines) and test out your camera of choice (if possible) before buying.

EOS 5D MARK II
The EOS 5D Mark II is a popular choice amongst photographers.

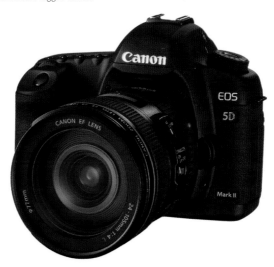

Lenses

As important as which camera to buy is the decision regarding which lenses to use. In general, I always recommend that photographers buy the most expensive, fastest lenses that they can afford. Why? Because you could have the best camera out there, but if you don't have good glass it will go to waste. Choose carefully—the lenses in your wedding kit could cost you more than the camera itself, so I would suggest that you rent or borrow some of the different lenses that are available to figure out what would work for you before you purchase anything. There are several great online lens rental companies, and many camera shops that cater to pros offer rental programs.

Many of the professional camera bodies are now full-frame. However, there are still some camera bodies that have cropped sensors. There are several lens options that were made specifically for camera bodies without cropped sensors. In the Nikon line, they are called DX lenses. The 35mm 1.8 $f/2.8$ and the 10.5mm $f/2.8$ are two examples of DX lenses. For the most part, you do not want to use DX lenses on a full-frame camera body (although there are some exceptions to this rule). If you are starting out with a full-frame camera or if

24MM 1.4
My favorite wide-angle lens from Nikon, the 24mm 1.4 (released in 2010).

50MM 1.4
The new Nikon 50mm 1.4 with improved bokeh and handling.

you are planning an upgrade to one in the near future, it would probably be a wise decision to pass over the DX lens line entirely.

Prime vs. zoom is a popular debate—I believe that it all comes down to style and personal preference. Primes have a wider maximum aperture than their zoom counterparts, allowing you to choose a very shallow aperture of up to 1.4 (for some Nikon lenses) or 1.2 (for some Canon lenses). I shoot primes because I like to shoot available light whenever possible, and shooting at an aperture of 1.4 and an ISO of 6400 I can virtually shoot in the dark. I also shoot primes because I like the shallow depth of field that they give me. I can throw the background out of focus while my subject remains in sharp focus. I also appreciate the lighter weight (although there are some heavy primes out there) of primes and feel comfortable shooting one-handed if there is a prime lens on my camera body. I do currently use one zoom lens (the Nikon

14–24mm ƒ/2.8) as a specialty lens for open dancing on dance floors where space is at a premium and for fireworks and sparklers.

Zooms also have their place, and I know many professional photographers who choose zooms over prime lenses. Zooms are wonderful because of the flexibility that they afford. In addition to the Nikon 14–24mm ƒ/2.8, I own several top-of-the-line Nikon zooms. I keep them primarily as backup, but I do use them if the situation calls for it. For example, if my access to the ceremony is restricted or if I have limited mobility during the ceremony for some reason and I know that I am going to need to be in the 100–200mm range, I will choose to photograph the ceremony with my Nikon

70–200mm ƒ/2.8 rather than my trusty 85mm ƒ/1.4. If I am trying to photograph the shy child in the wedding party who tries to hide under the table whenever I approach, I will photograph her with my 70–200mm somewhere in the 180–200mm range so that I can get a great shot of her without getting close. When I use the 70–200mm, my subjects usually have no idea that they are being photographed, which produces very real expressions.

BELOW Long lenses are great for photographing children because you can do it without drawing their attention. The same is true for ceremonies, when you don't wish to be obtrusive. Here is a photograph of a child during a ceremony. Taken at 200mm with Nikon's 80–200mm 2.8 lens.

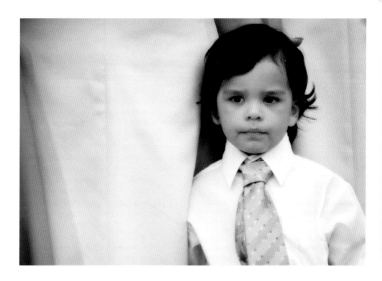

The fisheye lens is another tool that some photographers choose to use—it is extremely wide and produces a warping effect around the edges of the photograph. I love my fisheye—it adds variety to my ceremony and reception shots because my 10.5mm or 16mm lenses are wide enough to photograph the entire scene. I also use my fisheye for different portraiture, although I am always careful to keep my subjects in the center of the frame to avoid warping of faces. If you are not fond of the fisheye look but like the extra width, you can take a look at the wide lens options (in the Nikon line-up the 14–24mm ƒ/2.8, 17–35mm ƒ/2.8, 24mm ƒ/1.4 and 14mm ƒ/2.8 are all great options) or you can purchase software that will allow you to de-fish your shot. There are several products available that will help you to do this, but the best that I have found is carried by *DxO* (http://www.dxo.com).

A macro lens is also useful for capturing detail shots. I love to use my 60mm ƒ/2.8 lens to photograph so many of the small details, including the rings, the cufflinks, place cards and more. If you do not want to spend a large amount of money on a lens that might see limited time on your camera, check out the minimum shooting distance on some of the lenses that you already own. For example, if I

FISHEYE

LEFT Here is an example of a fisheye shot—notice the rounded horizon. This was taken with the Sigma 16mm on the D2X. I photographed this in Manual, knowing that the bright horizon would fool my camera's meter. It was taken at ISO 400, f11, 1/500.

CANON TS-E

RIGHT Professional-grade tilt-and-shift lenses include detailed controls.

LENSBABY

BELOW RIGHT Similar effects can be had with the LensBaby range of optics, for orders of magnitude that require less investment than a traditional tilt-and-shift lens.

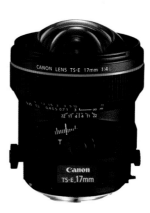

am covering a wedding that requires me to carry all of my equipment on my person rather than stashing a bag somewhere (or leaving one in the car), I will leave my macro at home and opt to use my 35mm f/2 instead, which allows me to take photographs of objects at close range. Another alternative to the macro lens is a set of macro filters that can be placed on your lens to allow you to simulate the look of a macro lens.

There are other specialty lenses which you may choose to utilize. The tilt-shift lens will allow you greater control and creativity when it comes to depth of field and perspective, and there are some professional wedding

photographers that do amazing work with these types of lenses. The Lensbaby is another fun option—it gives you the ability to choose a small part of the frame that will be in focus and then it gives you a graduated blur from that spot of focus. You can control the amount of blur and the precision with the type of Lensbaby that you choose.

Lights and Transmitters

Even if you prefer to shoot with available light, it is almost always necessary to have a flash or secondary lighting source with you. I will talk about how I light a reception in a later chapter, but for now let me recommend that at the very least you purchase an on-camera flash. Not all on-camera flashes are created equal—purchase one of the latest models and you will have an intelligent flash that works well on TTL mode and also allows for full manual control, as well as a flash head that swivels in all directions allowing you maximum creativity when it comes to lighting your reception.

There are many photographers that also choose to work with a video light. A video light is a great tool for adding a creative touch of light to the scene. There are many models, from the $30 Sima SL20-LX (which my good friend Jamison Wexler uses with great success) to Lowel kits costing hundreds (if not thousands) of dollars. Once again, your selection should come down to budget, portability and practicality—whether you work with an assistant, or how often you see yourself using the video light, for example.

If you are planning to work with off-camera lighting, then a flash cord (the SC–28 or SC–29 work well for Nikon) is a simple solution, although it limits you in terms of the number of lights that can be used and the distance from the camera that you can place the lights. You can also use a set of smart speedlights that "speak" to each other (Nikon speedlights offer a creative wireless speedlight system in which one camera acts as a master and controls the others). While these are great, they usually require a line of sight to the master speedlight to function properly. The option that offers you the most flexibility would be a set of radio transmitters. There are some great brands out there, and each comes at a slightly different size, price point, and with different options on board. I have a set of Pocket Wizards that work well, and I have also played with a set of Radio Poppers and I found them to be excellent. If you would like to do more research on radio transmitters to see which set might work well for you, head over to the Strobist forum (http://www. strobist.blogspot.com) where you will find a wealth of information on this and other lighting-related topics. Whether you work with one light on-camera, one light off-camera, or several lights spread over a few locations, it is always a good idea to have backup flashes on hand as these can and do burn out from time to time.

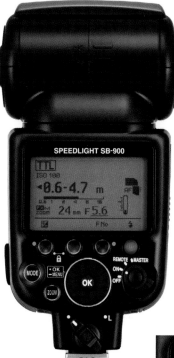

OFF-CAMERA LIGHT

The Nikon Speedlight SB–900 is one of many
options for mobile off-camera light.

Other Accessories

There are many accessories that you will need when you photograph a wedding. First, you will need to make sure that you have enough memory to get you through the day. I shoot Raw on the Nikon D3S, and I routinely fill over 30gb of cards on a wedding day, not including the 8gb card that I shoot as backup in the second slot of my camera. Memory is relatively cheap these days, so make sure that you have enough of it to get you through the day. It is not a good idea to dump your cards onto a computer or third-party device and then erase and reshoot them—occasionally there can be a problem on transfer (a faulty card reader, a glitch in the download, a card error) that you won't be aware of until you really have time to go through the files and look at them. There are some fabulous card recovery programs out there, but they won't work if you have reshot the card. Have enough memory on the front end and you can avoid any potential problems down the road.

You have all of the equipment, but you need to make sure that you have a way to power it. You will need to make sure that you have an adequate supply of camera batteries to power your cameras (I generally change my camera battery once during a wedding day), and enough AA batteries to power your flash throughout the day. If you have a video light, you will need a special battery or adaptor to power the light. It is also a good practice to bring the chargers with you in case you need them throughout the day.

Now, how are you going to carry all of your equipment? There are so many bags on the market, and it is important to find a system that is going to work for you. Remember, you need to keep your equipment accessible and secure during the long wedding day, and there are going to be times throughout the event where you will be unable to keep an eye on your equipment yourself. I use several bags to get me through a wedding, but the most important is my Go Bee bag (http://www.gobeebags.com). If I knew that all of my equipment would be stolen at a wedding and I could choose to hang onto just one thing, it would be my memory cards. Equipment can be replaced, and I have insurance to cover a theft or an accident. What I can't replace are the memories that I have already photographed, so I make sure that I have my cards in my possession at all times.

If you know that you are going to have a camera bag in your possession at all times, there are a few systems that have memory card compartments built into them. The Boda bag (http://www.goboda.com) offers quick access to cards, lenses and several other accessories. If you are traveling light, the Shootsac (http://www.shootsac.com) has several pockets for lenses and other equipment. When I use the Shootsac, I secure a card wallet to the Shootsac strap with a clip to keep it securely attached to one of the side pockets. I personally like a combination of form and function (and I don't carry a lot of equipment), so I love using the Epiphanie bag (http://www.epiphaniebags.com). The Crumpler (http://www.crumpler.com) also offers a lot of size options (and color combinations) and the Kelly Moore bag (http://kellymoorebag.com) offers a few alternatives to the Epiphanie-style bag.

When I need to travel with my equipment, I like using the Urban Disguise Series from *Think Tank Photo* (http://www.thinktankphoto.com). With room for a laptop built in, these bags are airplane-security-checkpoint friendly.

PORTABLE BACKUP

Copying and verifying your cards can be done even before
you load your cards onto your computer. You can do it
straight after the event with a portable device such as this.

If you like to carry a lot of equipment
with you, you might consider a rolling bag—
Lowepro, Tenba, Think Tank and Tamrac all
offer a variety of models. I would recommend
that you head over to a camera store (or, even
better, to one of the photography conventions
with a tradeshow) so that you can test out a
few of the bags and find the one that works
for you.

There is one other accessory that I carry
with me that I find to be extremely useful.
The Nexto Extreme copies and verifies my
cards for me after an event. It is not an image
viewer, so you cannot use it for image review,

but it does create a backup copy of the event
in a short amount of time. I like to download
the cards as I drive home. You simply set the
Nexto Extreme to Auto-copy and Auto-verify
and then plug the cards in one by one. Then
I copy them to my computer when I arrive
home. The verification stage gives me peace
of mind in that it is checking the copied files
for errors or problems. There are other card
storage devices available, but many of them
also come with viewers and much heftier
price tags. I want my Nexto Extreme for
downloading, backup and verification, and
it does those things extremely well.

Preparation

The Wedding Day

Post Production

Computers and Software

As digital cameras evolve, file sizes are getting bigger and bigger. As I mentioned earlier, I routinely shoot 30gb or more of images as each wedding. What does this mean for your computer setup? It means that unless you want to spend a lot of time waiting for your images to load, you will probably want to invest in a good computer.

Mac or PC? I have been using Macs for as long as I have been a professional photographer, so I have no personal experience with PCs. However, I can say that I have worked side by side with another photographer at a seminar—she was on a PC, I was on a Mac—and we opened the same images on our machine and processed them at similar speeds. Whether you go with a top-of-the-line Mac or the top-of-the-line PC, you will have similar results. The operating systems are different, so it all comes down to what you are comfortable with. When buying a new computer I always make sure that I upgrade the Ram and the hard drive—I always want as much Ram as my computer can support and the largest hard drive I can get without sacrificing write times. This speeds up the processing times considerably. You will also need to consider the screen— the sleek glossy screen that comes standard on the iMac may look beautiful, but if you are a stickler for 100 percent accurate color management you may not be happy with it in the long run.

What else do you need? Once you have processed your images, you will need to back them up. I back up my images to four hard drives (one lives off-site in case of fire) and three DVDs (one lives at a different off-site address). To make sure you don't lose work while you are working on your images, you might also consider a RAID setup. It is important to have both—RAID protects your day-to-day work while externals protect your long-term work. You might also consider an online solution (*Backblaze*, *Carbonite* and *Mozy* are complete online backup solutions, while *Zenfolio*, *Smugmug* and *Pictage* cater to images and offer sales as well), although unless you have a blazing-fast internet connection and the bandwidth to spare, this might be a practical solution for the finished images rather than the size-hungry originals. Redundancy never hurts, so you should use a variety of setups.

You might also consider a dual monitor for your workstation. When I work in Photoshop I like to have my actions and layers palettes readily accessible, but I also like to have my image taking up the maximum amount of space on the screen to make editing easier. I have found that a dual monitor setup gives me the best of both worlds—it allows me to have my images open on one monitor and have my palettes and other useful tools on the other screen. Whether you choose one monitor or two, laptop or desktop, make sure that you calibrate your monitors on a regular basis to ensure that the way that your image appears on the screen is the way it will appear on another calibrated screen or in print. Spyder, Eye-One and Huey Pro all offer a variety of options for the photographer looking to calibrate the studio monitors on a regular basis.

Once you have captured your images, you are going to need a way to process them. The specific programs that you need will depend on what type of image you shoot (Raw vs jpeg) and what you plan to do with the images. There are many fantastic Raw conversion programs out there—Adobe

IMAC

One of the newest iMacs from Apple. This computer comes with a glossy screen standard, so you may want to have a second screen for editing if you use this model. As always, make sure that you calibrate your screen.

MACBOOK PRO

The MacBook Pro from Apple. This is the computer that I use for the majority of my work.

Camera Raw, Adobe Lightroom and Apple Aperture are among the most popular (and there are other excellent programs, as well) and they each have advantages and disadvantages. Fortunately, most of them have trial periods so that you can test them out and compare the processing abilities and interface of each. When I evaluate programs, I take the same set of images and process them through each program. I try to find a program that is intuitive for me that produces the results that I like best. All of these programs are excellent, but I have settled on Adobe Lightroom for my Raw conversions. I like Adobe Lightroom because I find the interface to be extremely user-friendly, and I like the output options that it provides. The different modules, crop modes and spot removal speed my workflow along—I have been doing my initial edits in Lightroom since the beginning of 2006 and I have cut my workflow in half because I can do everything

that I need to do (with the exception of more complex image manipulation) right in Adobe Lightroom. We will discuss Raw conversion in detail later in the book, so if that is of interest to you, then you will hear more about it when we get to post-processing. We will also discuss some of the time-saving presets that are available.

By far the most popular and versatile program for image enhancement and manipulation is Adobe Photoshop. If you are just starting out and are balking at the price tag attached to the full version of Photoshop, you might consider starting with Photoshop Elements, which is a watered-down version of the bigger program. I do believe that Photoshop is an indispensable tool and is necessary for many complex adjustments and for advanced retouching, so purchasing the full version will not be something that you will regret. Of course, there are many actions available to help you achieve a polished

image in Photoshop, and we will discuss some of my favorites when we get to post-processing in the latter half of the book.

There are some other plugins that I use from time to time when I am editing, and I wanted to quickly mention them here. Topaz DeNoise is my favorite plugin for removing digital noise. As cameras become more sophisticated and are able to take usable images at high ISOs, the need for noise removal becomes less pronounced. While I used to run noise removal on a number of images per wedding back in the Nikon D1X days, with a D3S and a correct exposure I find that now months go by when I don't need it at all. However, the need does arise from time to time, and it is a nice tool to have. I also like the lens-correction software available from *DxO* which can help de-fish a fisheye shot or fix some of the distortion present due to use of an ultra-wide lens.

ADOBE BRIDGE

OPPOSITE Adobe Bridge is a great program for basic sorting and renaming. It is a great platform for batching in Photoshop as well.

ADOBE LIGHTROOM

ABOVE This program is great for everything except more complex image manipulation.

CAMERA SETTINGS

There are several different things you will need to decide when setting up your camera. The first big decision is Raw mode vs jpeg? If you are shooting a DSLR, then I would recommend that you shoot in Raw 100 percent of the time. Whether I am on the job or photographing my kids at their soccer game, I shoot Raw. It gives me so much more flexibility when I "develop" the image. Instead of letting my camera process the file for me in-camera in order to give me a jpeg file, the Raw file keeps more data and therefore allows for more latitude on exposure, white balance and contrast. While the jpeg file can also be modified, it has so many more limitations than its Raw counterparts. A few years ago, camera buffers and write speeds were so much slower, and shooting Raw meant that you were often waiting for your camera to catch up; however, cameras in 2011 are faster, more sophisticated machines. Most DSLRs are able to write Raw files faster than you can fill up the buffer, which keeps you from experiencing any lag time when shooting. With more sophisticated DSLRs and fast Raw processing programs (Lightroom and Aperture), I really see no reason *not* to shoot Raw, because the benefits far outweigh the drawbacks.

I do have one setting on my camera that is set to jpeg, and that is my backup slot in my D3S. One of the reasons that I shoot with the Nikon D3S is that it has dual compact

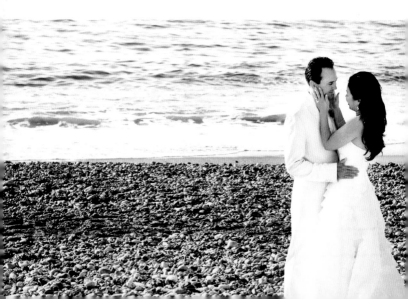

flash-card slots (the top-of-the-line Canon offers the same). I know some photographers use them as overflow, so that when they finish shooting on one card the camera will switch and start filling the other card. I, however, choose to use it as backup. Why? I have had a compact flash card fail on me in the past. While you are more likely to experience image-loss due to user/operator error than you are to experience image-loss due to a faulty card, there are those of us who have lost images due to faulty CF cards. While I only had a handful of images that couldn't be recovered (and none of them were images that my client missed), it was enough to make me vow never to shoot with one card again. So, I have one 8gb card and one 16gb card in my camera at one time. The 8gb card (slot one) is set to shoot Raw. These are the files that I manipulate and send to my client. The 16gb card (slot two) is set to shoot jpeg (medium/fine). I chose medium-fine because it gives me a six-megapixel image with the least compression. If I needed to (because of a catastrophic card failure), I would feel completely comfortable delivering those images to the client. Because the file size is so much smaller, I can usually keep a 16gb card in my camera without filling it up with jpegs for an entire event (even a multi-day event). So, the 16gb card stays in-camera and never moves while I keep filling the 8gb cards with Raw files and switching them out.

LEFT The bright sun, the water acting as a reflector in the background and the white dress and suit—all three combine to make a photograph that is very difficult for the in-camera meter, so I chose Manual.

Therefore, I always have an immediate backup system and will end the wedding with two sets of files.

The second big decision is your choice of exposure mode. Essentially, you have four choices: Program; Aperture Priority; Shutter Priority and Manual. In Program mode, you are letting the camera decide how to expose the image. You could end up with a wide depth of field and a slow shutter speed in one shot and then a shallow depth of field and a fast shutter speed in the next. I rarely shoot in this mode because of the lack of control that it gives me. It should be noted here that if you have a prosumer- or consumer-model SLR, they will occasionally add more modes such as Night mode or Action mode—these are essentially tweaked versions of Program mode.

In Aperture Priority mode, you set the aperture that you want the camera to use and then the camera calculates the shutter speed. I tend to shoot in this mode about half the time—I almost always want to shoot with a wide aperture which will give me a shallow depth of field (pleasantly out-of-focus background and foreground with sharp subjects). I shoot in Aperture Priority when the lighting will change quickly, necessitating different exposures from shot to shot while I am moving quickly. While my cameras are quite good at determining the exposure, I constantly have my hands on the exposure-compensation dials because I know when my camera will tend to over- or underexpose a scene. For example, if my bride is in a huge white dress on a white sandy beach on a bright day, I know that the camera is going to underexpose that file because of all the white in the photograph. If I am photographing a groom who is wearing a tux and standing in

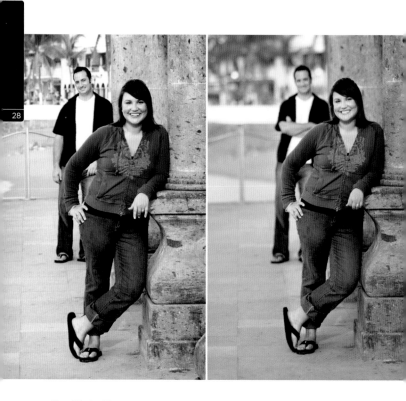

ABOVE Most of the time, I like to work with a shallow depth of field (a wide aperture), as shown on the right using 1.8. It draws attention to the subject (the woman) and throws the background (the man and the scene in the back) pleasantly out of focus.

front of a dark background, the camera will overexpose the file because it sees so many dark colors in the frame. It's important to know your camera well and to understand how it handles different situations. If you have a new camera, it is a good idea to test it out in a few different scenarios and constantly chimp (look at the back of the camera at the image) to see how the camera is doing. I set my image review to flashing highlights mode—this will show me if my camera is overexposing the highlights—and I use my exposure compensation button to better control how the camera is exposing the image. Why don't I just shoot in Manual so that I have complete control? I like the flexibility that Aperture Priority mode gives me in fast-action, light-changing situations, and I know my camera well enough so that I end up with properly exposed images at the end of the day.

In Shutter Priority mode, you set the shutter speed and the camera sets the aperture. I use this setting if I am photographing in changing low light and I need to have a minimum shutter speed. Generally I make sure that I am shooting at 1/60 of a second for my wider focal lengths and about 1/100 for my longer focal lengths. I can shoot down to about 1/10 of a second comfortably for steady subjects with a wide-angle lens, but experience motion blur when I go lower than that. Your ability to handhold at slow shutter speeds will be different—I know some photographers who can handhold down to very slow shutter speeds (and, of course, Vibration Reduction lenses can help), so make sure you test it out for yourself to determine where your comfort level is.

In Manual mode, you will have total control over the image because you are setting both the aperture and the shutter speed. I use this mode around half of the time at a wedding. I shoot on Manual when I am comfortable that the lighting is not changing quickly and that I will have adequate time to tweak it if I need to between shots. Generally I use Manual for ceremony shots, formals, and reception shots. I like the control that this mode gives me over exposure and I spend less time checking my images because I have carefully set the camera to expose the image the way that I want it to. If you shoot on this mode, be cognizant of sudden changes in lighting (a cloud passing over the sun or a dimmer switch being operated). While your camera will see and react to the changing light in the other modes, *you* are the one who is responsible for seeing and reacting to the changing light in Manual mode. If you miss the change, you could be left with images that are not usable.

OTHER THINGS YOU SHOULD KNOW

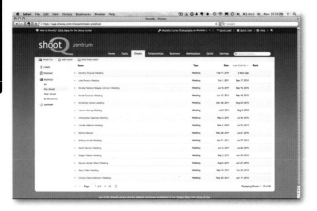

You have the kit, you have an interested couple, you understand your camera and take wonderful images, but are you ready to photograph the wedding? There are still some things that you should have in place before you photograph a wedding.

Insurance: You are rolling the dice if you are photographing weddings without insurance. Not only will you be hurting financially if your gear gets lost, stolen or broken (many home-owner/renter insurance policies do not cover camera equipment, especially equipment that is used commercially), but you could also be liable if someone gets hurt because of your gear or while you were photographing them. Let's say that you set your lightstand in the corner of the dance floor and you are happily triggering your external lights with your Radio Poppers while the guests are on the dance floor. Suddenly, one of the groomsmen careens into

the lightstand and knocks it over and it hits someone on its way down. Check the laws in your country, but in the United States you will need liability insurance to protect you from such things. If you are in the US, then you may want to consider joining PPA (www.ppa.com). One of the biggest benefits of membership is this included liability insurance and access to a legal team in case a suit is brought against you.

Contracts: Even if you are shooting the wedding for a family member or a friend or as an assistant to a professional photographer, it is important to draw up a contract, especially if money is changing hands. There are several good pre-made contracts available, but I'm partial to those from the *Photographer's Toolkit* (http://www.photographerstoolkit.com). Of course, you will want to have your lawyer take a look at the contract before you use it, since laws may vary in your state, but these

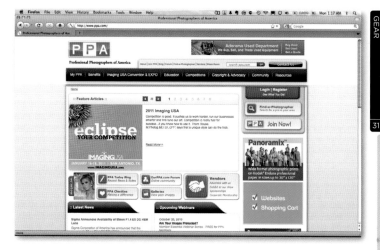

offer an excellent starting point and cover all the necessary bases (disputes, claims, delivery, unexpected images—anything that could potentially become a source of conflict). Once you have your contract in hand, you can either send out paper copies or you can use an Internet studio management solution. I currently use *ShootQ* (http://www.shootq.com), and it allows my clients to sign electronically and return my contracts, plus it keeps track of billing, leads and booked dates for me. Another good option is *Tave* (http://www.tave.com), which essentially does the same thing with a different interface.

Questionnaires: Both *ShootQ* and *Tave* allow you to send your clients detailed questionnaires. When you first establish contact with your clients you can use these questionnaires to figure out how they heard about you, where they are having their wedding, what their budget is and who their

ABOVE If you are a photographer working in the United States, then PPA is a must. Their indemnity insurance and the access to a legal team would be worth the price of membership on their own, but this is also a fabulous organization for business advice and inspiration.

OPPOSITE *ShootQ* allows my clients to sign contracts electronically and helps me keep track of billing.

coordinator is. Once they have booked with you, you can use the questionnaire to ask detailed questions about their wedding and about the major players. Are there any nasty divorces in their families that you need to be aware of prior to photographing the family formals? Are they having any special events? We will review some of the questions later, but keep in mind that there are resources out there that can help you organize your questionnaires within a virtual client folder.

PREPARATION

Good preparation not only ensures you'll have a much smoother workflow during the shoot, it will also be much more fun for you and your client. The more relaxed you are, the better you can direct the bride and groom. Preparation is also key for building confidence—once you have mastered the basics, you can always cope with the unexpected.

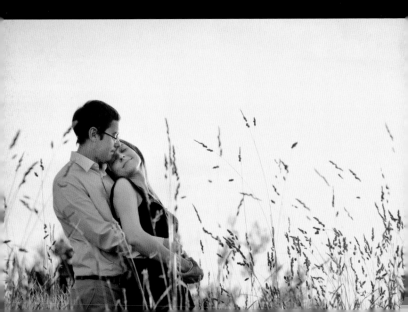

ENVIRONMENTAL PORTRAITS AND POSING

I sell myself as a photographer that offers a combination of documentary wedding coverage and environmental portraiture. My clients have carefully chosen their wedding location (whether that refers to the specific venue or the region in which the wedding is being held), and they want to showcase it in their wedding photographs. I try to loosely pose my clients in a way that I can highlight their environment, their details, the weather —anything that will feature the things that make their wedding uniquely theirs.

You will hear a lot of photographers say that they are uncomfortable posing clients. Perhaps it isn't what they love, or perhaps it is outside of their comfort zone. For years now, working with my couples to create environmental portraits has been one of my favorite parts of the wedding day. I have broken it down into a series of six steps.

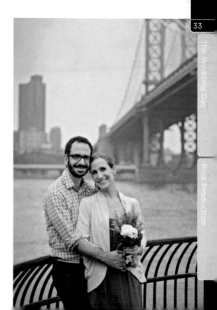

RIGHT An urban portrait from an engagement shoot. Here the couple are smiling and relaxed against the strong, but muted shapes of a city landscape.

LEFT In this engagement portrait, the golden sunset and the field location combine to heighten the romance in this photograph.

Step One: Vision

Perhaps the most important step in the process is the first. The Vision step is important because this is where you see the location and decide on the backdrop for your photo. Although Photoshop is a later step, this is also the step where you want to visualize your end product—how are you planning to post-process your image? What elements do you want to enhance? What elements do you want to minimize? What is it about that scene that draws you in and would make a dynamic environmental portrait?

For many photographers, when they look at a location the Vision step is instantaneous—they know what they want to do from step one. However, this step can sometimes benefit from a bit more thought. Walk around the scene—look at it from different angles and *really* examine the light. Where do you find the best light and the best backdrop? How will the light (and backdrop) affect your exposure?

When analyzing a scene I tend to look at several different things:

Shadows: Is there an interesting shadow pattern that makes the scene more intriguing? If so, how can it be enhanced or played up in the photograph?

Repeating Elements and Patterns: Is there repetition in the frame? If so, how can I emphasize it to create a more dynamic photograph?

Leading Lines: Are there strong leading lines in the frame that will strengthen the image? How can I frame the photograph to make the best use of those lines?

Reflections: Can I make use of a reflection in the photograph to create a more interesting composition?

Symmetry: Are there any natural dividers in the frame? How can they be used to make the photograph more dynamic?

Color: Are there strong colors and will they enhance (or detract) from the image? I love bold colors and I try to use them whenever I see them.

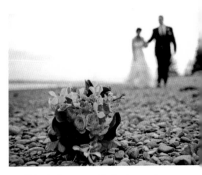

Light: Is there a spot in the frame where there is amazing light? If I rotate my position and frame it differently, how will the light fall differently in my frame?

Environmental Elements: This one is my favorite—are there any elements in the frame that give the photograph a sense of place? Is there anything that speaks of the environment in which the photograph was taken? Every couple that I have ever met has decided on their wedding location for a reason—they love the ocean or the mountains, they grew up on that particular lake, or it was the place where they first met. What is it about the location that makes it special, and how can you capture the location in the photograph?

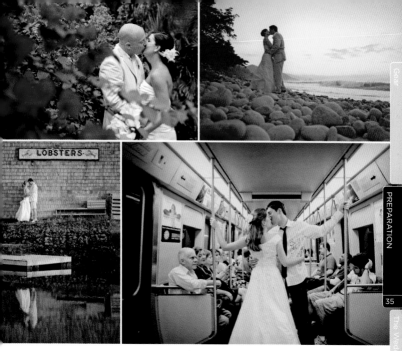

OPPOSITE Here the fairly similar rocks provide repetition broken by the extremely colorful bouquet. The bouquet is offset by the couple on the other side of the frame, and the color of her jacket helps to balance out the photograph.

TOP LEFT I chose this spot for the amazing color and the environmental elements. The flowers were climbing up the side of the building and by shooting through them I was able to give the photograph the feeling of a private moment. This was photographed at $f/3.2$ to throw many of the flowers into an out-of-focus area without creating so shallow a depth of field that the flowers became unidentifiable.

TOP RIGHT This beach is known for its beautiful rocks. I dropped down low so that I could really emphasize the variety of colors and their size relative to the couple.

BOTTOM LEFT I love reflections, and the still water here provided an opportunity to get a fabulous reflection. I chose to stop short of a mirror image by not including the sign in the reflection, which gives the eye a strong focal point instead of two conflicting points of interest.

BOTTOM RIGHT This is an example of leading lines—the lines of the subway form a diagonal into the couple. Even the handrails and the position of the couple draw your eye into the center of the frame. What I love best about this shot, though, is the expressions of the passengers—from complete indifference to interest, they run the whole gamut.

Step Two: Placement of the Couple in the Frame

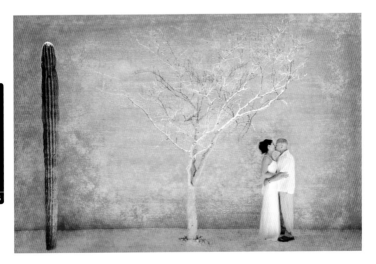

Before you even give your couple the most basic directions regarding their body position or their interaction with one another, it is necessary to place them in the frame. You probably thought about this during step one, especially if you had leading lines or good light—where can you place the couple to maximize the effect of some of the elements in step one? Or, at the very least, where can you place the couple in the frame so that they detract from the scene in the most minimal way possible?

When I place my couple in a frame I am constantly aware of the rule of thirds and my negative space. Very rarely will I place my couple in the center of the frame—I only do

so if I have some strong leading lines that pull you right into the center or if I am trying to center them within a frame of some sort (a door or window or other framing device). Most of the time I use a lot of negative space in my photographs in order to make a more dynamic composition and to give weight to the environment as well as to the couple.

Take a look at the photograph above. If there hadn't been a cactus on the side of the frame opposite the couple, this would not be as strong a composition. As it is, the tree is central and the couple off-sets the cactus, creating a balanced and dynamic composition. The photograph on the bottom right (opposite) is an example of a situation

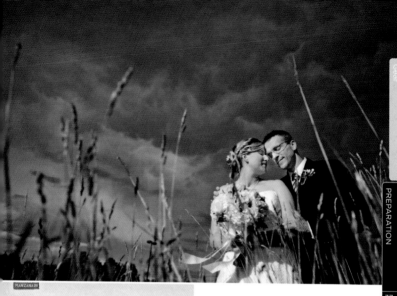

OPPOSITE, LEFT AND ABOVE In these portraits the positioning of each couple creates the impact, be it through balance or imbalance.

where it made sense to frame the couple. Notice the framing element present (the doorway). Placing the couple within the doorway frames them within the environmental object of interest. In the photograph above I placed the couple in the bottom half of the frame to emphasize the storm clouds in the sky. Because I ducked down, the tall grass actually appears to be taller than the couple (which it wasn't). I placed the couple in that particular spot because of the gap in the tall grass— notice that the grass appears to be pointing to the couple, which draws the viewer's eye directly to them.

Step Three: Position

ABOVE Chest to chest is one of my favorite positions because it is an easy pose. I photographed this with my 50mm lens and I dropped down low to emphasize the grass on either side and to hide the distracting background.

Now it's time to put the couple into the photograph—before you tell them what you want them to do in the photograph, you need to get them into the right spot and in the appropriate position relative to one another. This step is all about their connection with one another (not their emotional connection, but their physical connection relative to the camera). There are several different positions that you can put them in—obviously your options will be limited by the choices you have made in step two and their comfort level with you/the camera and with each other, but you should have at least several options from this list to draw from in every environment and situation.

Chest to Chest: This position implies a certain level of intimacy and, depending on the couple, you may have to refine the pose a bit. The important thing to remember is that this is a "joined" position—really make sure that they are touching. If there is confusion, ask them to hug (and not the butt-out hug that you might give an acquaintance) and then refine the position from there.

Back to Chest: This position is a safe one to start with if you have clients that are having difficulty warming up to the camera. Either person can be in front—you do not necessarily need to put the shorter person in front as long as you choose an appropriate interaction from step four. Some people will automatically go into this pose if you say "cheesy prom photo!" but this position will become anything but that depending on the action/interaction that you end up choosing. If you keep your distance and

let the pose naturally evolve, you may end up with a couple that has essentially curled around one another. If you keep asking them to cuddle and get closer, you can make this position much more intimate.

Sitting on or Between the Legs: There are two options with this position—the chest-to-chest version and the back-to-chest version. Obviously, the chest-to-chest version is more intimate and can take more coaxing and explanation. Be sure to refine this position if the legs of either person are too far apart, or if there is too much slouching (or possibly not enough slouching). This position also works well on stairs.

Sitting Side by Side: Whether on chairs, on a wall, on stairs, or on the ground, this pose works well with almost all couples. You may have to refine their positions and/or give them more direction so that the couple is more connected to one another—they can appear very detached from one another depending on their body language. You may want to correct their sitting positions and connect their hands in some way. You may also need to tell the groom to close his legs.

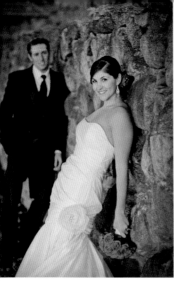

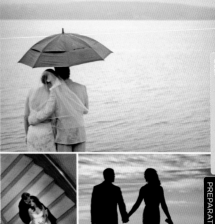

Standing Side by Side: This is another simple position, although you will want to be very aware of their body language and will want to refine the pose if they look too detached from one another.

In the Same Frame, Separated: There are many ways that you could position them here—perhaps you want to put one person in each door frame or hanging out of different windows. This can be a very fun pose that allows for a lot of creativity, although it does limit your action/ interaction options in step four.

One Sitting, One Standing: This can be a very sexy, fashion-forward pose depending on how you connect the couple and the action/interaction that you choose in step four.

Lying Down: Whether they are lying with their feet in the same direction or in opposite directions, this position can be a very intimate one to photograph.

ABOVE LEFT I love shooting with prime lenses so that I can shoot at a shallower depth of field than $f/2.8$ provides. This was photographed at $f/2$ to keep the bride in sharp focus while throwing the groom into an out-of-focus area.

TOP RIGHT Sometimes the best poses are those in which the couple feels comfortable and natural. They naturally went into this pose, and all I had to do was change my perspective in order to see their heads underneath the umbrella.

BOTTOM CENTER I love the intimacy of this pose, and shooting down on the couple adds to the privacy of the moment and takes the distracting background out of the shot.

BOTTOM RIGHT I wanted to separate the bride and groom while keeping them connected. I asked her to turn her hips away from him and take a step forward while looking back over her shoulder at him. I exposed this photograph for the sky to emphasize the colors and create a beautiful silhouette.

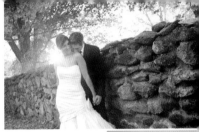

Step Four: Action and Interaction

Now that you have the couple in the frame in a basic position, it is time to set the mood of the photograph. Two photographs with couples in similar body positions can take on two very different moods simply by tweaking the interaction within the photograph. There are some actions and interactions which are more awkward for some clients, while others simply require a "warm-up" period before you start getting into the more intimate interactions.

If I find that a client is embarrassed by any of the interactions, I either start slowly and give them a less intimate interaction or I turn my back under the pretense of "changing a lens or a memory card" or "checking something" for a minute or two to allow them to warm up to one another.

Looking at the Camera: Some couples will naturally lean away from each other—unless that is the look that I am going for, I usually have to tweak this interaction and ask them to go cheek-to-cheek or to get closer to one another. "Snuggle in" is the term that I use. I don't create many portraits of them looking at the camera, but it's helpful to have a few.

Forehead to Forehead: This is another easy one because it can be performed in front of friends and family without embarrassment. The other nice thing about this interaction is that it gets them really close together, and they usually end up laughing because they are in so close. Most of the time I will tweak this pose by having them close their eyes.

Cuddle: There's a lot of mileage in this interaction—whether it's the side cuddle,

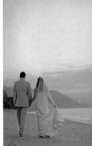

ABOVE I asked the groom to kiss the bride's temple while I fiddled with my exposure to properly capture a touch of flare in the shot. Because I stepped back and stopped directing them, the pose evolved into something better.

RIGHT If you have a couple that is nervous about posing, give them a task. I wanted to show the bride's dress, so I asked her to hold the train out to the side. I photographed this with my 50mm lens.

back cuddle, or front cuddle, it's really easy to ask them to just "cuddle." Occasionally I will ask them to close their eyes and rotate their heads toward me just a touch, so that I can actually see both of their faces without having them look at the camera or be straight on to the camera. I also try to connect them at as many points as I possibly can.

Kiss on the Forehead: This is a great one if you have a groom who is significantly taller than the bride. You'll get a different feeling in the photograph by changing up what you ask the bride to do—if she closes her eyes, then you will create a more intimate portrait. If she opens her eyes and looks straight at the camera while his eyes are closed, you will create something a bit bolder.

Kiss: My favorite, and one of the easiest to ask for. Don't be afraid to tweak the kiss by having them change their head positions—

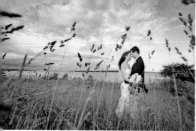

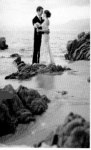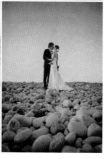

TOP A very easy interaction to start with is forehead to forehead. If you have them close their eyes it is extremely easy for even the most camera-shy couples to relax.

BELOW CENTER This was photographed with my 85mm 1.4 at ƒ/3.2. I asked the couple to go chest to chest and get close together without kissing, and it produced beautiful smiles on both of their faces.

LEFT The kiss is an easy interaction for most couples. This was photographed with my 24mm lens at ƒ/3.5 to keep the rocks partially in focus. I was careful to keep my couple in the center of my frame as the 24mm can create noticeable distortion on the edges of the frame.

remember, you want to avoid making it look like one person is eating the other person's face and you want to make sure that you aren't hiding one person.

Movement: Another easy one, this one gives a lot of variety as you can shoot them moving away or towards you, fast or slow, walking, skipping, jumping or running. I tell them that I don't want them to look at the camera, but that I would prefer that they talk to and look at one another, interacting with each other rather than the camera.

Holding Hands: An easy stationary position to accomplish, you can tweak the mood by changing the distance they are from one another, and whether they are looking at each other, looking at you, or in different directions. If you don't like the mood of the photograph you are taking, simply change their distance from one another and where they are looking.

Head on Shoulder: Sometimes the side-cuddle ends up at this position— occasionally, though, it is easier just to ask for this position in the first place, especially if you have a couple that needs more direction.

One Looking at the Camera, One Not: This is another position that can be combined with some of the others, or it can stand just as well on its own. The mood of this shot will be affected by whether the person looking at the camera has a huge grin or is serious.

Detail Shot with the Couple as a Backdrop: This is another one of my favorites. When I refer to "detail," I don't necessarily mean the details from the wedding, although those are good too. Almost anything can be used as a detail—the rocks on the beach, the flowers growing by the side of the road, or the antique car. Most of the time my detail shots are taken with a very shallow depth of field so that the detail is in sharp focus and the couple is pleasantly out of focus.

Step Five: Choose Your Perspective and Settings

Of course, a big part of how the final image will look depends upon where *you* are positioned and what equipment and settings you choose to use. Are you going to take the photograph from below or from above? From a lower perspective to minimize or from a higher perspective? Emphasizing an object in the foreground or cropping in close to have the couple fill the frame? Are you going to choose a slower shutter speed to emphasize movement, or are you going to choose a shallow depth of field to separate your subject from the background? Are you going to try to incorporate flare in the photograph? The same position/interaction from a different perspective can yield a very different photograph. If you mix and match the positions and interaction/ actions, you will come up with more than a hundred potential poses. If you add perspective to that as well, you can double the number of possible photographs. Look at the photographs below (middle and right), for example. That is the same

location, the same body position and the same interaction. Those shots were photographed seconds apart, but because I changed my perspective and used a different lens, I have two very different photographs there.

When choosing a perspective, here are some things to think about:

1. Minimize the background. Get low and shoot up at your couple. You may find that your background is only what's in the sky (which may be some interesting cloud patterns).
2. Minimize everything except the couple. Crop in closely on the couple. It doesn't matter where they are at that point, since they are filling the frame.
3. Maximize the foreground. Get low on the ground and shoot straight at your couple.

BELOW CENTER A nondescript putting green behind the couple was easily hidden by moving in close to the flowers to make them look as tall as the couple. I photographed this with my 50mm lens at $f/3.5$.

BELOW RIGHT Maine is known for lobsters and this couple wanted to have a bit of fun before dinner, so I focused on lobsters with my 35mm lens and threw them partially out of focus at $f/3.5$.

BELOW LEFT This groom's unique wedding hairstyle just begged to be highlighted, so I turned the groom to emphasize his hair while bride maintained eye contact.

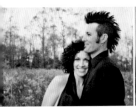
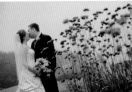

ABOVE This classic car was an important detail at the wedding. I moved in close with my 24mm lens to increase the size of the car in the frame relative to the tree behind it.

ABOVE In order to draw attention to the water and the interesting landscape, I put my 28mm 1.4 on the camera and crouched down close to the water. I didn't want my couple to get lost in the trees on the left side of the frame, so I pulled them to my right until they cleared the trees entirely.

If you choose a shallow depth of field, you can either sharply emphasize the foreground and keep your couple out of focus or you can emphasize the color, shape or texture of the foreground only, while keeping your couple in sharp focus. Or, of course, you can stop down and keep both in focus.

4. Emphasize the sky. Think about doing a silhouette and expose for the sky. Or, think about adding a bit of fill flash or video light to balance the proper sky exposure with the proper couple exposure. I rarely add any light to my scenes, but I know that there are people who use external light sources with fabulous results.

5. Include flare in your shot. Stop down to f/13 or beyond, choose a lens that flares easily, and dance around your couple until you get the amount of flare you want.

6. Shoot a detail with the couple in the background. Choose a shallow depth of field and fill your frame with as much of the detail as you can without pushing the couple out.

7. Emphasize the couple *and* the immediate surroundings. Position your couple on the ground and shoot down on them or place the flowers/leaves/ferns in the foreground and shoot the couple through them.

Step Six: Tweak the Pose and Take the Shot

The photograph is almost done. You have chosen your location (step one), set the couple in the frame (step two), set their body positions (step three), directed their interaction (step four), and chosen your perspective, lens and camera settings (step five). This is the time to reevaluate the pose and tweak it if necessary. So many people take a less than perfect shot with the excuse that they can "fix it in Photoshop later." Well, unfortunately for those people, while you can tweak your colors, elements, light and contrast in post-processing, it is very difficult and often impossible to fix the pose after the shot has been taken. Check for things that look awkward in the frame. Does the groom have a hand just hanging by his side? Is the bride's shoulder tensed up? Is the bride slightly hidden by the groom and do you need to ask them to rotate so that you can see both of them better? Although I don't follow the traditional rules of portraiture, *per se*, this is where knowledge of them can come in handy:

1. Don't cut the hands off at the wrist or the feet off at the ankle. If you are in danger of cutting the couple off at the ankle, back up or ask them to back up, or get closer so that you can cut them off farther up the leg. Same with the hands; either back up or ask them to lift the hands and embrace the other person.

2. Create space between body parts to avoid the "blob" look to slim your couple. If they are too pressed together, ask for another interaction.

3. If it bends, break it. Other than when you are lying down, how often are you comfortably sitting or standing with all of your joints completely straight and locked? Almost never. It looks (and feels) awkward and is usually a sign of discomfort in your couples. Bend those elbows and unlock the knees. Bending the elbows, especially, will create space between body parts and have a slimming effect on the bride and groom.

4. Connect up stray body parts. You are standing at the airport, ready to say

LEFT I wanted to have the couple's heads in the break between the two rocks, so I ducked down and positioned myself with my 85mm 1.4 so that their heads would clear the rocks without breaking the horizon.

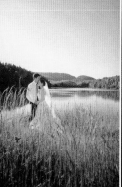
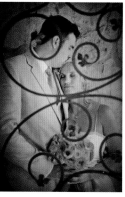

TOP LEFT The incredible light on the couple and the colors in the sky provided a beautiful backdrop. To keep almost everything out of the background, I put the couple on a wall and turned them toward the sunset while I dropped down in front of the wall.

BOTTOM LEFT To create a less distracting background while focusing on the sky, I photographed this shot with my 85mm lens while lying on the ground.

CENTER I used my 24mm lens to create this shot of the couple. They stood on the path just behind the tall grass, but because I photographed through the grass it gives the illusion that they are standing in the middle of the tall grass.

RIGHT The scrollwork of this gate framed the couple nicely. I photographed this at f/1.6 with my 50mm lens so that the swirls would add to the scene rather than competing with the couple.

goodbye to your loved one and you lean in for a passionate and tearful kiss. How often do you lean in for that kiss with your butt out and your hands at your side? Not very often, as that doesn't say passion. Have your couples embrace each other, get as close as they can, connect their hands or put their hands around each other, and bring their legs in closer together. In short, they should be connecting on as many points as you can find.

5. Look for slouching and correct it. Sometimes you have to tell them to engage their stomach muscles and create the illusion of good posture.

6. Look for body tension and correct it— the "claw hand," lifted shoulders, droopy heads, raised chins, butts out—if you see something tense, ask them to relax.

7. Give the hands something to do. This one is related to point 4—you need to connect up the body parts. Nothing says disinterest more than a hand laying limply at the side. Give that hand something to do—embrace something, stuff it in a pocket, hold a bouquet, put it on the groom's chest or hold hands.

8. Avoid bouquet strain. A big bouquet can cause tension and ugliness in the forearm. Don't be afraid to ask the bride to put it down or have the groom hold it.

9. Watch the arms around the neck as this position will sometimes make them look big. Ask her to put her arms around his waist instead (under his arms).

STYLE AND TECHNIQUES
Documentary Photography

Even though I really enjoy working with my couples and creating environmental portraits, for the majority of the wedding day I am not interacting with them; rather, I am documenting their wedding day as it happens. While I am not a true photojournalist (and there are amazing resources out there if you are looking to improve this aspect of your shooting, such as Foundation Workshops, the Mountain Workshops, and more), there are some techniques that I use to create a much stronger image.

First, I try to anticipate the action.

ABOVE By standing quietly on the side of the church and observing during the Catholic Mass, I was able to capture the bride sharing a fun moment with her maid of honor. This was shot with the 85mm 1.4 at ƒ/1.8.

Weddings, while unique, all follow the same formula. The players, traditions, timelines and locations may all be different, but in most weddings the basic event is going to be the same. Anticipate reactions before they happen—the groom's reaction as the bride walks down the aisle, mom's reaction to the maid of honor's speech to the bride, or the

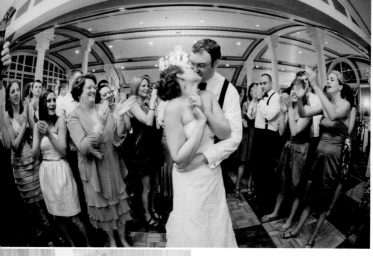

ABOVE All of the people important to the couple were on the dance floor to observe their farewell dance. I wanted to capture all of their reactions, so I put my fisheye on one of my camera bodies and waited for the right moment.

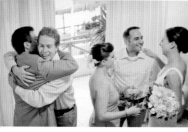

LEFT The bride and groom share a moment with the members of their wedding party immediately after the recessional. This was photographed with a 28mm 1.4 at ƒ/3.2 to keep most of the people in focus.

crazy dancing that erupts during the first dance set. Keep your eye on all of the major players, and look for action elsewhere as well.

Second, I try to compose a stronger shot that encompasses more of the action. If I am photographing the groom's reaction to the best man's toast, then I want to frame the groom with the best man's outline. That way, it doesn't just look like a photograph of the groom laughing; rather, it gives you the context as well, since you can see that the best man is giving a speech. I try to look wider than the moment that I am looking to photograph. You may want to photograph the

bride looking at herself in the mirror, but if you look wider, you may see her mother getting all emotional as she observes the bride looking at herself in the mirror. If you compose the moment carefully, you can include both of them in the frame.

Third, I pay attention to my foreground and background. There may be something extremely interesting in the foreground that I will want to include to add a sense of place or humor to the photograph. Or perhaps there is something distracting in the background that will pull the viewer's eye away from the bride and groom. I try to pay

attention to everything that is in my frame—or everything that *should* be in my frame—in order to create a stronger composition.

Finally, I try to pay attention to the "planned" events that do not appear on the timeline. Occasionally a surprise will be planned. If it is a surprise for the guests, then I'm always in on the secret. But if it is a surprise for the bride and groom (surprise fireworks, fire jugglers, a touching poem, a funny dance), then I will often be as surprised as the bride and groom if I'm not paying attention. Talk to the wedding planner, the moms, or the maid of honor to see if there are any other events planned—one of them

is almost always in the know. If you are surprised, you will have more of a chance of getting the shot if you have quick access to the equipment you might need at all times. I travel light, and often shoot with the 24mm, 35mm, 85mm and fisheye lenses throughout the day. I carry those lenses with me at all times and, if something happens, I can always get the perfect shot.

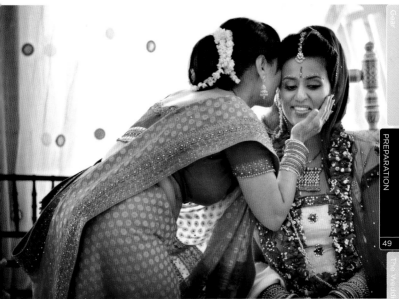

ABOVE Here I have captured a special moment between a bride and her maid of honor.

LEFT The bride peeks out of the window right before the ceremony. I wanted to keep her in shadow and create a soft silhouette, so I underexposed the shot.

OPPOSITE The bride and groom loved this band and never left the dance floor, so I wanted to capture a fun moment that clearly shows them enjoying the music while also showing some of the band. I used my fisheye to fit everything into the frame and kept them in focus by shooting at $f/4$.

Lighting a Room

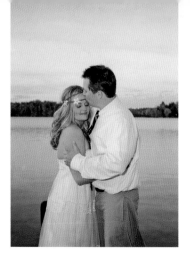

Although I prefer to shoot with available light, there are times when manipulating the light through creative use of additional light sources can improve a photograph—for example, when I am photographing a portrait with strong backlighting, or when I am photographing at a dark reception. Before I begin talking about the techniques that I use to light a reception, though, it is important to review some basic principles of flash photography:

It is essential that you know your flash sync speed. For example, with my Nikon D3S, the maximum sync speed (without going into high-speed sync) is 1/250 of a second. That means that my shutter speed cannot be faster than that if I want to make adequate use of my light (without going into high sync speed, which takes a lot more power out of my flash). On some of my other cameras, the maximum sync speed is 1/200 of a second. Know what your camera supports, and you can work from there.

Remember that when you are working with a flash, your shutter speed only controls your ambient light, while your aperture controls the amount of light from your flash that falls on your subject (the flash's exposure). That means that if all else remains constant (your ISO, your flash power on Manual) and you want to increase the ambient (background) light in your photo so that you can see the candles on the table or the lanterns in the background, then you need to lower your shutter speed. If you are on 1/60 of a second, drop it to 1/30 of a second to allow more ambient light into the photograph. If all else remains constant and you want to increase the intensity of the light that you are creating with the flash, then you need to shoot with a wider aperture. If you

ABOVE A touch of flash was needed here, but I was surrounded by dark trees and had nothing to bounce off of. I pointed my flash to my left (and slightly behind me) and then bounced off of my hand to push just a bit of light forward to lift the shadows on their faces.

OPPOSITE TOP Because this reception was under the stars, I could not bounce off of the ceiling behind me. Instead, I bounced off of the walls of the building on my left.

OPPOSITE BOTTOM The light from the videographer allowed me to properly expose both the couple and the lanterns behind them. I stayed approximately 45 degrees away from the video light to get some great directional light on the couple.

are at $f/4$, try $f/3.2$ to increase the amount of artificial light on your subject. Of course, you can also increase or decrease the power of your flash or change your ISO, but if you are happy with those settings then it is important to remember that shutter speed controls ambient light, while aperture controls the flash's exposure.

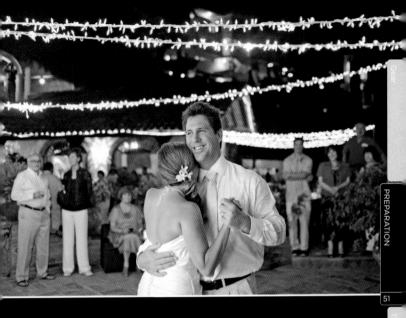

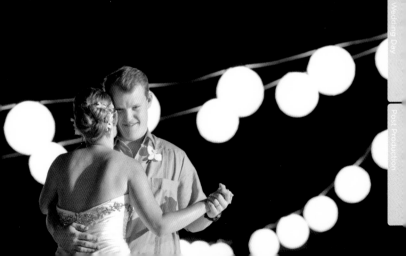

When I am working with flash I am almost always in Manual mode on my camera and Manual mode on my flash. When I enter a room and I plan on using my flash, the first thing I do is take an ambient light reading. I dial my ISO up as high as is needed and as high as I am happy shooting it (with the D3S I am happy shooting 3200–6400 throughout the reception with minimal noise if I nail my exposure), so if the reception is dark I may take an ambient light-reading at 3200 and one at 6400. Basically, this means that I turn my flash off and check my settings to see what I would need to be at (1/60 at 2.8?— 1/30 at 2.8?—1/15 at 2.8?) to have a good

amount of ambient light in my shot.

Most of the time, if I am in a light-colored room or tent that is fairly uniform throughout, I have one flash on my camera, pointed up and behind me to my left. I bounce my flash off of the wall to create a directional, soft light. You can change how dramatic your light is by changing the angle of the bounce or the power of the off-camera light as compared to the ambient light.

Occasionally I like to bounce my flash off of different surfaces to direct the light. You can bounce light off of walls, ceilings and floors to produce beautifully lit photographs that produce little or no flash shadows and

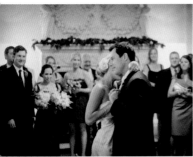

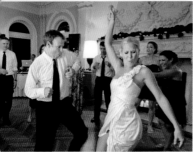

LEFT This was photographed at 50mm, ƒ/2.0 and 1/125. I bumped the ISO up to 4000 in this dark room so that I could keep my shutter speed high enough to cut down on motion blur.

BELOW The flash bounced straight off of the wall directly to my left to create the directional light on the couple. Because I was bouncing straight to the side rather than up, I made sure to check for people standing between me and the wall that might have interfered with my light bouncing off of the wall.

OPPOSITE The shutter speed was set at 1/40 to bring up the ambient light in the shot while I bounced my flash behind me and up, and turned slightly over my left shoulder to create a directional light.

can often simulate the look of soft window light. You will need to be aware of the color of the surface that you want to bounce your light off of, as this can affect the color of the light that bounces back on your subject. If you are interested in learning more about bounced flash, Neil van Niekerk has some incredible tutorials regarding the creative use of flash on his website (http://www. planetneil.com).

If there are limited options for bouncing, then I will occasionally take my flash off-camera. If I am going to take it off-camera, then my first choice is to use a flash cord (the Nikon SC-28) so that I can hold the flash off-camera (with the cord connected to my camera's hotshoe to trigger the flash) while I shoot. This can get tiring after a bit, so if I am going to be shooting off-camera flash for any length of time then I set one flash up on a tripod and use my Pocket Wizards to fire it (you can also use Radio Poppers or any other radio transmitter). Most of the time I prefer to use one light, but if I want to add some fill flash then I will have one Nikon speedlight on my camera and one on a tripod or clamped in a convenient location.

If you are interested in learning more about off-camera lighting, there are three great resources available. Zack Arias (http://www.onelightworkshop.com) has instructional material available that is extremely helpful when you are venturing into the realm of off-camera lighting. *Lighten Up and Shoot* (http://lightenupandshoot.blogspot.com) also has some great information and tutorials as well as before-and-after photographs. The *Strobist* forum (http://www.strobist.blogspot.com) has a wealth of information on lighting on their blog and in their archives, and they also run assignment series to get you practicing creative lighting.

Capturing Flare

One of the questions that I am frequently asked by other photographers and hobbyists is how to take a shot that has sun flare in it. I love the look of the sun's rays shooting through the frame and wrapping around my subjects. Contrary to what most people believe, it's not a Photoshop trick—it's done in-camera and it's actually a fun technique to master, although you should be careful of your eyes when photographing straight into the sun.

First, be aware that some lenses flare more easily than others, and some produce better flare than others. For example, I am a Nikon shooter (the D3), and I dislike the flare from my 50mm 1.4. For the purposes of my work I steer clear of that lens when I am trying to produce flare in-camera because I dislike the look of the flare that it produces (unless I am silhouetting my subject). The rays are less defined and will often be punctuated by bright green bubbles in the most unfortunate spots. On the other hand, I love the flare that my 28mm 1.4 produces and I don't mind the flare that my 35mm 2.0 is capable of producing. So, if I am going after nice, intentional flare, I will choose a lens that provides me with the most pleasing flare that I can get. Whether your flare shot succeeds or fails (according to the vision that you have in your mind) can often be determined by something as simple as your choice of lens. If you have chosen poorly, then you could be dooming your flare shot from the start. How can you find out if your lens produces beautiful or ugly flare? Usually a google search can help you, but if all else fails and you are choosing between lenses that you already own, simply test them out in the same conditions with the same subjects within minutes of one another. You may not see the difference through the lens, but I guarantee that you will see the difference in the results.

BELOW LEFT I wanted to silhouette my couple, so I dropped down low to get the upper half of their bodies in front of the sky. I underexposed the sky to retain the colors and to create the silhouette. This was photographed at ƒ/13.

BELOW RIGHT This was photographed at 35mm at ƒ/5.6. I switched to spot-metering to make sure that I was metering for the faces of my couple rather than the sun behind them.

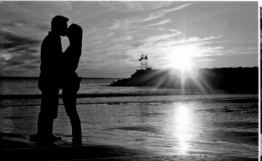
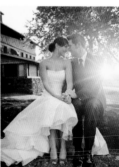

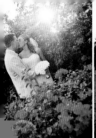
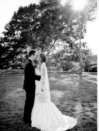
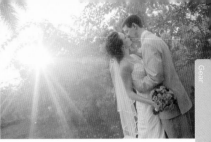

I absolutely love shooting with a very shallow depth of field—I like to shoot my lenses close to wide open, and I am usually shooting at an aperture of 1.4 to 2.8. One of the only times that I stop down (if you don't know what that means, "stop down" is what we say when moving to a smaller aperture/higher number) in-camera is when I want to take a flare shot. If I want less-defined flare, I might keep it at f/5.6, but if I really want prominent flare, I might take it to f/13 and beyond. What happens to my flare shot if I forget to change my aperture and leave it at 1.8, for example? I will still see the flare, but it will show up as a haze rather than defined rays of light across my frame. This is the type of flare that can be replicated in Photoshop—the Boutwells, creators of the Totally Rad Action Set (http://gettotallyrad.com), have a few actions that will add this hazy type of flare to your shot. As pretty as that can be, most of the time when I am after a shot with flare, what I really want to do is capture the defined rays. Therefore, it is important to be cognizant of the fact that your camera settings will definitely affect the type of flare that you are capturing in your frame.

After I have chosen my lens and changed my camera settings, I frame my subject. The flare that you will get in your frame is affected by the angle of your lens relative to the sun, as well as the angle of the light relative to your subject. It is really easy to overdo the amount of light coming into the frame and completely blow your shot. Play

ABOVE LEFT TO RIGHT

I only wanted a touch of flare to come through the flowers here, so I shot my 28mm 1.4 at f/5. It was tricky to get the sun in just the right spot through the flowers, but I was able to do it by having my couple stand still while I shifted back and forth.

This was shot at f/14 with my 28mm 1.4 to lengthen the rays coming into the background.

By shooting my 35mm lens at f/9, I was able to keep the defined edges of the flare as it comes through the tree behind the couple.

around with it, moving around the light and around your subject. Flare will often work best if the sun is wrapping around your subject or another object. Flare also works well when it enters the shot from the edge of the frame; you can achieve some beautiful rays of sun shooting across your image even when you aren't shooting directly into the sun. Once you have set up your subject, shoot a dozen frames so that you have different flare patterns to choose from.

Keep in mind, if you don't shoot on Manual, that the camera will want to underexpose your subject because of the amount of light entering the frame. That will work if you are going for a silhouette effect, but if you want detail then it will be important to shoot in Manual or use exposure compensation when shooting into the sun.

Capturing the Sunset: Silhouettes and Fill Flash

A sunset can be a beautiful thing to photograph, and if there is a gorgeous sunset during your wedding or engagement session you can bet that your couple will want it incorporated into their photographic coverage. There are two different ways I capture an amazing sunset or an incredible sky at dusk—either with a silhouette or with an image that has a touch of fill flash.

The silhouette is one of my favorite images to take, and it is easy if you follow a few basic steps. First, remember that the greater the percentage of the photograph that the sky occupies, the more dramatic your silhouette photo will usually be. When I am setting up my silhouette photograph, I try to elevate my couple. This can be accomplished by having your couple stand on a hill or by lowering yourself to the ground. If you are on a beach or in an open field, this is an easy task. If you are in a city or a forest, it's going to be a tougher assignment, so you may want to scope ahead of time to look for a potential location. Pay attention to the body position of your couple—if they are too close and intertwined, they may look like one big blob in the photograph. Try to make certain that they have space between them and that their individual shapes are clearly defined. Finally, you want to expose the image for the sky. If you slightly underexpose the image, it will bring out the beautiful colors in the sky. I try to photograph the image at a higher f-stop than I normally use because I want to move directly from a silhouette shot to a lit sunset portrait and I want to make sure that my shutter speed is lower than 1/250 of a second, so that I can photograph the image without using high-speed sync.

To create the beautifully lit sunset photograph, you simply need to add some light to illuminate the couple. Use your exposure from the silhouette photograph—unless you use high-speed sync, you will want to make certain that your shutter speed is slower than 1/250 of a second. If the sky looks beautiful, all you will need to do is add light to illuminate the couple. This can be accomplished in a number of ways. The easiest is if there is a videographer present and his video light has enough power to illuminate your couple while properly exposing the sky. Otherwise, you can fire your flash. I like to put my flash directly on-camera and bounce it off of something to the side of me to create a beautiful, directional light on the couple. I put my flash in Manual mode and simply fiddle with the flash power to find the appropriate ratio. If there is nothing to bounce off of, I might use my flash off-camera (either using a Pocket Wizard or a cord) so that I am still able to get directional light on the couple.

LEFT After you shoot your silhouette photograph you can capture your couple in amazing light by turning them around and putting your back to the sun. The sunset behind me threw a nice warm glow onto my couple while the sky behind them turned pink.

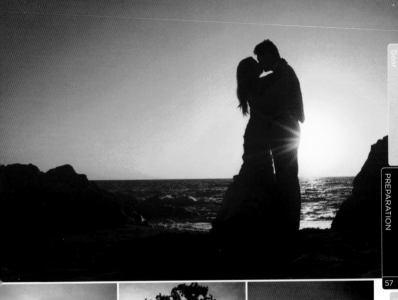

TOP It is important to keep a bit of space between your couple so that they don't end up looking like a single blob with undefined edges. I asked the bride to lean against the groom with her upper body while keeping some space in between their legs. This was photographed at ƒ/10 to create the flare peeking from behind the silhouetted figures.

ABOVE LEFT By bouncing my flash off of the wall behind me I was able to capture the beautiful colors in the sky while lighting my couple. Because I bounced the flash off of the wall and at an angle I was able to throw a softer light onto the bride and groom.

ABOVE CENTER Because I wanted to photograph the silhouette of the couple and the tree, I made sure to duck down and put the couple far enough away from me that their heads wouldn't intersect the tree branches.

ABOVE RIGHT If you wait a few minutes after sunset you will be able to photograph the deeper hues in the sky. This was photographed with my 24mm at 2.8.

Capturing Fireworks

I LOVE fireworks—a good fireworks display can stop me dead in my tracks. So I find it incredibly fortuitous that approximately half of my forty weddings per year involve pyrotechnics. I guess my clients love fireworks just as much as I do, and it's just another reason that I absolutely adore my couples.

One of the questions I am often asked is how to photograph fireworks when you are trying to include the couple in the frame. Now, there is more than one way to skin a cat and there are certainly a lot of ways that you can capture great photographs of fireworks at a wedding, but here I am going to tell you how I do it.

First, it is important to understand that not all fireworks displays are created equal. When you find out that there are going to be fireworks at your wedding, there are some very important questions that you need to ask. Where are they lighting the fireworks and in what direction are they planning to shoot them? How long will the show last, or (even better) how many are they planning to light? Where is the closest spot that the couple can stand? Maine, like many states, has very strict laws governing the use of fireworks and there will be a clear line that may not be crossed legally.

Next, you will need to make some observations. Which way is the wind blowing and how hard? If it is really windy, this may affect the accuracy of the placement. In that case, you may need to choose a spot for your couple that gives you more flexibility to move and frame them. How much moisture is in the air? If it is humid or foggy, the light will bounce off of the moisture in the air creating an interesting effect and giving you more available light to play with. How close will the couple be standing to a light source? If they

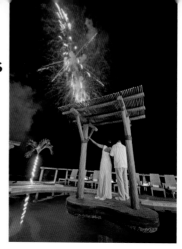

ABOVE I really wanted to pull out the ambient light coming from the pool, the tree and the fireworks, so I shot this at an ISO of 6400 at 1/25 and ƒ/3.2.

are near a building, lamp or a video light it will affect your exposure and how you balance the light on the couple with the light from the fireworks.

Finally, I prepare my couple for the display. I tell them that I will be shooting at a low shutter speed and I ask them to remain still (hugging each other, of course) for at least a few moments during the display.

Most of the time my favorite fireworks photographs include no additional lighting. I love shooting fireworks with the light given off from the fireworks themselves and from any additional light sources that are close to the couple (the venue, for example). However, because the fireworks may end up (due to wind or poor placement) farther away from the couple than is ideal for providing the right amount of light, I always have my flash mounted on my camera and I will take at least half with my flash as well. I have enabled one of the function buttons on the front of

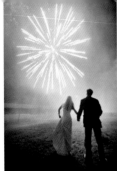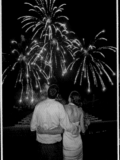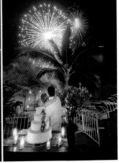

ABOVE LEFT Because of the moisture in the air, when the fireworks were lit they illuminated the couple from many different angles. This was photographed at 14mm, 1/8 of a second at ƒ/2.8. You will need a couple that is comfortable standing still if you plan to shoot at that speed without a flash.

ABOVE CENTER I wanted to sculpt the couple with my flash, which I bounced off of the darkened building behind me. I photographed this at 18mm with my 14–24mm at ƒ/2.8 and 1/30.

ABOVE RIGHT I photographed this at ƒ/3.2 and 1/50 of a second with my 14–24mm. I was careful not to overexpose their white cake in front of them, which is one of the reasons I chose not to use flash in this particular situation.

my camera to disable my flash so that I don't have to bother turning my flash on and off—I just hold the button down and the flash will not fire. The photographs above left and right were taken with existing/available light, while the photographs above center and on the opposite page were taken with a flash firing. They provide very different looks, so it all comes down to preference. I prefer the photographs taken with available light, but I like to provide my couples with a variety (and occasionally I will surprise myself and like one of the flash photographs better, too).

I shoot with the Nikon D3S, so I am very happy with the camera's files at 6400 and I set my camera's ISO to 6400 for the fireworks display. I use my 14–24mm 2.8 because I usually shoot fireworks in the 18mm range and I like the flexibility that the zoom offers. (This is actually the only zoom I use, and I bought it specifically to use for fireworks and sparkler displays although it has crept into

regular reception use now as well.

When I am photographing the fireworks without a flash, I generally shoot at 1/8 of a second at 2.8. I'm comfortable holding my camera steady at 1/8 of a second at 18mm, but you will definitely want to test yourself before you try it out on a job. When I am photographing the fireworks with a flash I try to bounce it behind me (onto a building or tent or even a person standing there) to provide some directional light. Occasionally nothing with be available and I will point the flash up with a white card (to provide a tiny amount of light bouncing forward). With the flash on I often photograph at 1/25 of a second at 2.8 with my flash on Manual.

Obviously those settings are where I start and I take some test shots prior to the start of the display and adjust once the fireworks start if need be.

Capturing the Venue at Night

The venue, whether it is a hotel, a tent, a restaurant or the great outdoors, will look very different at night. If the venue is blazing with light, it is a photograph that the bride and groom will love and it is one that the venue will love as well because it is a different take on the standard venue shot.

First, you need to choose the best time to take the photograph. You can take it right after sunset if you would like to catch some colors in the sky, but it may be too bright to capture much of the ambient light. If you wait about 20 minutes longer, you can capture the dark sky with a bluish hue and you can pick up the glow of the ambient light. Generally I want to take the photograph before it is completely pitch black, but 20 to 30 minutes after sunset. Depending on where you are and the geography around you, the timing will vary.

Next, be prepared for some really low shutter speeds. If I am not rushed, I am comfortable holding my camera at 1/8 or even 1/4 of a second. However, these photographs may require a shutter speed of a second or even longer, depending on how dark it is and how much ambient light spilling out of the venue that you have to work with. I don't carry a tripod with me, but if that is something that you like in your kit, this is the time to put it to good use. If, like me, you don't have a tripod with you, anything can be used to stabilize the camera. I will grab a chair or a table or even a car and place my camera on that to hold it steady.

I like to shoot this on Manual, but it can be done on Aperture Priority if you crank up your exposure compensation. You will want to overexpose the photograph to bring out the blue in the darkening skies. I generally meter the scene and then set my camera 1/3 to 1 full stop above that reading. I like to shoot the scene anywhere between 800–1600 ISO.

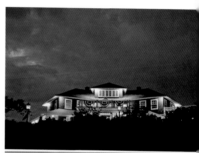

BELOW The sky was quite dark when I shot this, so I bumped my ISO to 4000 and shot at 1/40 at *f*/2. I used spot-metering to read the scene and I adjusted my exposure from there.

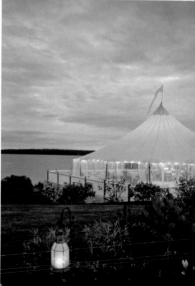

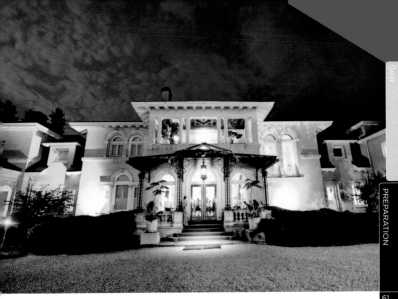

ABOVE It was quite dark when I had a chance to head out to photograph this venue, so I needed to shoot it at 1/3 of a second at f/4 to bring out the blue in the black sky.

OPPOSITE BELOW Even though the sky was still quite light just after sunset, I wanted to retain some of the detail in the foreground so I shot this at 1/20 and f/2.5.

BELOW This reception area was extremely dark, so I shot at f/3.2 at 1 second. Because I was at such a slow shutter-speed I made sure to stabilize the camera on a chair. The slow shutter-speed kept the background in focus while showing the motion of the guests.

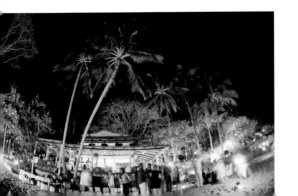

ENGAGEMENT SESSIONS

I really enjoy engagement photographs because they give me a chance to get to know the couple and have fun with them. It is also an opportunity for a photographic trial run, and it gives me valuable information about the couple. Does the bride fidget with her hands? Does the groom have a lazy eye? Are they blinkers? Do they cuddle up together naturally, or does it take a bit of coaxing? Are they comfortable in front of the camera, or are they nervous?

The engagement session also gives the couple a chance to get to know me and my style. Up until this point, they have seen my images, but they don't know how those images were captured. They don't know what to expect, and sometimes they are nervous about having their picture taken. The engagement session gives them a chance to have fun with me and get excited about their

photographs on the wedding day. It also gives us an opportunity to create beautiful images in an environment that is not stressful—there are no time constraints, there are no guests to worry about, and emotions are not running high.

My engagement sessions usually last at least an hour. They may run over if we are traveling to a few locations or if we really get in the groove and are having fun. I tell the couple how long engagement sessions usually last so that we are not pressed for time, and because I like to do on-location shoots using available light, I try to schedule my sessions for late afternoon, about two hours before sunset. That way, the light is becoming better towards the end of the session as they are warming up to each other and to me.

I also give my couples advice on what to wear or bring to the session. While I don't give them specifics, I do make sure that I give

BELOW LEFT This couple spent a long time living in a Mexican city after college, so we photographed their engagement session in Mexico and tried to capture the flavor of the side streets. This was photographed with my 85mm 1.4 at ƒ/4.5 to keep both the couple and the guitar player on the edge of the frame in focus.

BELOW RIGHT I love the symmetry and bold colors that this location provided. I didn't want the couple to break the mid-line, so I changed my angle and had them snuggle into one another so that they would stay in the lower half of the frame.

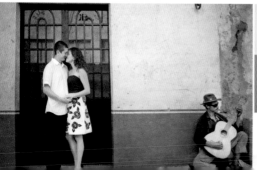

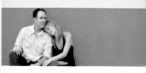

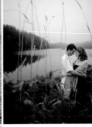
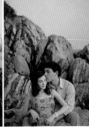

ABOVE I am constantly on the lookout for birds flying in and out of my frame. While it is difficult to predict, it pays to be prepared for the possibility.

TOP LEFT TO RIGHT

Because there was a fairly strong current on the day of their session, I had the bride and groom pick up some momentum, row into the frame, and then lean forward and kiss. That way I had a few seconds of leeway before the boat began to turn.

Whenever there is a foggy day I will try to photograph through plants or flowers in order to break up the gray of the sky. This was photographed at 24mm at $f/2.8$.

This couple planned a lakeside New England wedding, so they wanted their engagement session to capture the coast since we wouldn't get a chance to shoot there on the wedding day. This was photographed with my 85mm 1.4.

them some guidance on this point. I like my couples to be relaxed, and wearing clothes that they don't have to constantly tug at and readjust can really help them loosen up and lose the stiff look in photographs. I also want them to be able to cut loose and enjoy the session, so I encourage clothes that they are happy to get wet or dirty. If they are more adventurous, then I may suggest that they bring props to the session.

I always start out with a few standard poses. Refer back to the environmental posing guide for more details on how I pose my couples and compose my shots. The session usually evolves, though, as we get to know each other and start having fun, and partway through the session I find that I need to give fewer instructions as the couple relaxes and becomes more spontaneous.

The engagement session also gives you a wonderful opportunity to create some beautiful products for the wedding. If you photograph the session early enough, you can use the images to create visually appealing custom save-the-date cards and wedding invitations. You can also use the images to create an Engagement Book for the couple that can double as a sign-in or guest book at the wedding. Some couples even integrate the engagement photographs into their wedding favors or their table cards. The session can really provide them with a great opportunity to individualise their wedding.

Session 1:
Cate and Saro—Urban

Cate and Saro live in Brooklyn, and they wanted engagement photographs that would reflect their personalities and where they were at that time in their lives. Their wedding was in Mexico, so it was important that the engagement session reflect their life in New York. Cate wanted a vintage-themed session with a lot of fun props, so I encouraged her to bring as much as she wanted on the shoot. From the hats to the gloves, the outfits that she and Saro chose really reflected the look that they wanted. They also brought a number of props, including bubble guns, water balloons and chalk.

At the beginning of the session, I tried to incorporate architectural details that were unique to their neighborhood as well as some of the New York cityscapes. As we relaxed into the session and began to have fun, we brought out some of the props. I set up Cate and Saro with New York City as a backdrop, and they had a water balloon and bubble fight, which made for some fun photographs.

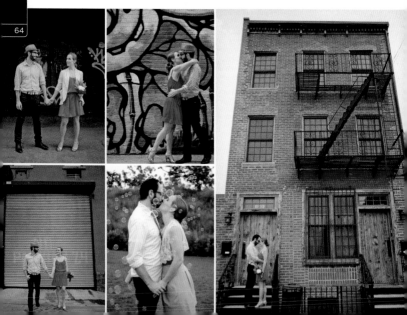

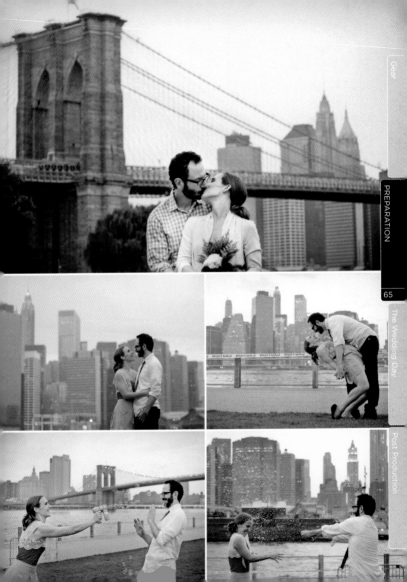

Session 2:
Abby and Colby—Country

When I met Abby and Colby, they had just moved to Maine from New York City and were planning a beautiful Maine wedding. I wanted their session to reflect a country beauty, and I chose a location with a scenic backdrop as well as long grass, trees and fences. I also wanted to incorporate some interesting light and flare into the photographs to give the sense of a sunny day in Maine.

We started the session in the standard fashion—I directed them into a number of loose poses and created some beautiful environmental portraits. As the session progressed, Abby and Colby began to interact with one another more, and I found that they had an incredibly easy way with one another and that they were naturally affectionate.

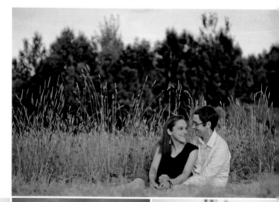

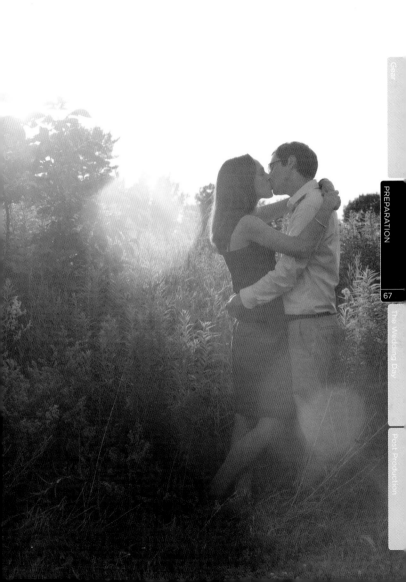

Session 3:
Dinah Maria and Tom—Beach

Dinah Maria and Tom planned a Puerto Vallarta wedding, so they wanted to do an engagement session in Mexico before their wedding as well. They wanted a combination of the gorgeous coastline, the colorful town, and since they were not planning on doing a Trash-the-Dress session they wanted to get wet during their engagement session as well.

I like to start my engagement sessions an hour before sunset, but since we needed to go from the town to the beach I wanted to start the session earlier. It was really bright, so we chose areas in town that were shaded by other buildings. Still, the light was really harsh so I chose a lot of nuzzling poses so that the couple could either focus on one another or close their eyes. When we arrived at the beach the sun had dropped considerably and the light was perfect for a beach session. I gradually moved them into the water, and when we ended with the sunset photograph I shot it as a silhouette so that you couldn't tell that they had wet hair and clothing.

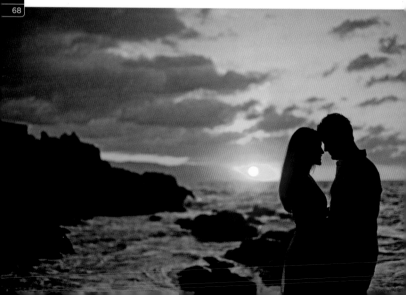

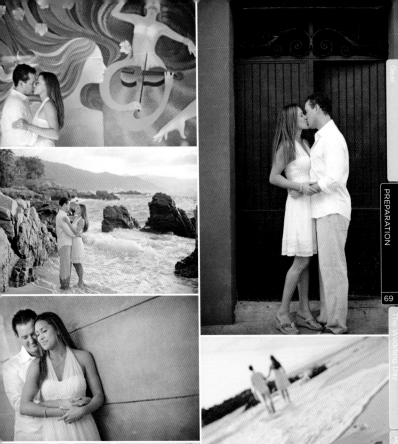

BOUDOIR

Many brides choose to do a boudoir session before or after the wedding day. Some of these brides want to give tasteful, suggestive photographs to the groom on their wedding day or anniversary. I offer an on-location boudoir shoot for these brides—I either go to their house or I rent an appropriate location (a hotel room with tasteful or fun decor and good lighting, or even a villa). The key is comfort—I want these women to be comfortable during the shoot and I have found my studio to be a very sterile, uncomfortable environment for this type of shoot. Not all studios are created equal, though. There are some photographers who do incredible work and specialize in studio

ABOVE If you can convince your bride to go outside, it's usually worth the effort. It was a freezing, windy day (it even snowed) but the series from outside was well worth it.

BELOW The backlighting here flatters the shape—make sure to either blow out the background entirely or drop down to avoid photographing anything through the windows in the background.

OPPOSITE At $f/2$ I was able to bring the focus of the eyes and lips. I shot from above, which is usually a flattering perspective.

boudoir sessions (even venturing into the pin-up style). Do what works for you and for your clients—you will create better images if both of you are comfortable during the session.

I work with the bride prior to the shoot to give her wardrobe, hair and makeup suggestions. It is extremely important that she feels sexy and gorgeous during the session, and the right wardrobe, hair and makeup can go a long way to putting a woman at her ease.

I tend to do shots that are more suggestive than revealing for our boudoir sessions. I tend to use window light for the majority of the shoot, photographing with a prime lens (usually a 50mm 1.4 or an 85mm 1.4) shot wide open. This produces beautiful, out-of-focus areas that are suggestive and flattering. When photographing women (in general, but especially when they are wearing lingerie), I make sure to photograph them from flattering angles, and often photograph them from above to elongate their necks and thin them out.

I choose the 85mm $f/1.4$ for the majority of the photographs because it is a fabulous portrait lens—it won't create a lot of distortion around the edges of the frame that a wider lens might create. I use chairs, beds and sofas as props and I tend to photograph them where they are most comfortable. I have them change outfits every 15 to 20 minutes, and I constantly give them verbal feedback.

I try to emphasize the eyes, mouth, or detailing on the lingerie, often using selective focus to draw more attention to these areas. I tend to do more post-processing with my photographs from boudoir sessions, as I want the skin to appear smooth and uniform in tone.

BELOW You can create an illusion of a bride without clothing simply by positioning the body and any straps creatively.

TOP RIGHT Watch your backgrounds—if there is a fireplace behind your subject, light it if you can, so that you can add a glow to the background. This was photographed at 120mm at $f/2.8$.

BOTTOM RIGHT Window light can be extremely flattering. I will often move a bed, or a piece of furniture that we are using, closer to the window to capitalize on the beautiful, soft light. This was shot with my 50mm 1.4 lens at $f/2$.

THE WEDDING DAY

The big day is here and you're ready to shoot. To
succeed in taking exceptional wedding photographs
you need to be prepared—make sure to have backups
ready in case of equipment failure, and keep on top of
what's scheduled (officially and unofficially), so you're
in position and ready to capture the moment.

Shooting a wedding can be a daunting task unless you know what to expect and you have a plan. While every wedding is unique, there are many similarities and your day can run like clockwork if you know when things are going to happen. That is why it is important to be in communication with the couple regarding the details of their wedding day—the times and locations of different events, how they are traveling between locations, how much time they are leaving for different photographs, and how the different locations will be lit.

It is also important to be in communication with the couple well in advance of the wedding day so that you can clarify their expectations and modify the schedule, if need be. Unless they have hired a wedding planner or they work in the wedding industry, couples rarely know when things are supposed to happen or how to make the day flow smoothly. Sometimes their expectations are unrealistic. It is much easier to address these issues well in advance of the wedding day than on the day of the wedding itself.

What kind of issues am I talking about? The biggest issue involves timing. One example is the timing and length of time allotted to formal photographs and the bride-and-groom photo shoot. I have worked with many couples that have chosen beautiful venues for their ceremonies. They envision

RIGHT I knew from chatting with the bride that their dog would be attending the wedding but that he would only be there for a brief time. As a result, I kept my eye out for his arrival so that I could get a few shots of him before he left.

LEFT Because I talked in depth with the coordinator about the ceremony and reception, I knew that the bride and groom were planning a complicated ribbon ceremony. While absolutely lovely, it did decrease mobility, but because I knew the plan for the ceremony I was prepared.

ABOVE LEFT After the ceremony the bride and groom sailed away. Because I had chatted with the bride and groom about the sail prior to the wedding day, I knew that they preferred shots of them from shore rather than shots taken on and around their boat.

ABOVE RIGHT The bride and one of her bridesmaids joked all day about the origin of these pinecones. It turns out that they obtained them when a pine tree fell on the bridesmaid's car and destroyed it, and the story was told several times throughout the day. Even though I generally focus on details as a rule, I made sure to get some extra shots of these placeholders because of the interesting backstory.

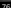

their photographs on the beach—beautiful location and interaction photographs—in the golden sun. Or they have visions of a dramatic view of mountains framing them in their photographs. Yet, when I go over their wedding schedule with them, they have scheduled their photographs well after sunset, when there will be no scenery visible at all. By talking to them ahead of time, we are able to either change the time of the shoot or clarify their expectations. If the times cannot be changed, they may consider seeing each other before the wedding, investing in a post-wedding shoot, or I will get them excited about low-light photography augmented by a video light. Perhaps the couple has chosen the perfect time for photographs, but they have only left 20 minutes and they want photographs at ten different locations. I make sure that I tell them how many photographs and what kind of photographs we can take in a given time-frame. It is important to me that the couple has realistic expectations about what can be accomplished in the time that

BEING PREPARED

LEFT Because the groom's mom had designed and set up the entire tent (with some help from her incredible friends), I tried to photograph the decorations from many different angles because I knew they were extra-special to the groom. Sometimes, the bride and groom have scheduled something really incredible for their wedding—fireworks during their first dance, sparklers at their reception, a special toast. They deal with so many vendors during their wedding day that they may forget to tell you about every event unless you ask for specifics. When I initially book the wedding, I will get a general timeline from the bride and groom and I will correspond with them throughout the planning process. However, a few days before their wedding I will also have a detailed conversation with them about any special things they might have scheduled and when they might be occurring. This includes events during the ceremony. For example, a bride and groom may be having a Catholic ceremony. This tells me many things about what I might expect during the ceremony, but it doesn't tell me much about the specifics. Some Catholic ceremonies have a crowning ceremony, some have a rosary ceremony, others have a presentation of gifts to the Virgin Mary, and still others have a coin ceremony. It is important that I have a clear picture of what is happening and when it is going to happen so I know where I want to stand and so that I'm not walking around looking for a better vantage point when they do something meaningful.

they have allotted for photographs.

It is also important to have a clear picture of the wedding party and the families. Are there bitter divorces in the family that will force you to treat the groom's family as two separate families during the formal photographs? Are you dealing with a large wedding party of 30 that will require extra time and attention during the wedding party photographs? Are there grandparents in attendance who are infirm and may not be able to participate in the formals but should definitely appear in other, less formal photographs with the bride and groom?

These are all important questions to ask and will help you on the day of the wedding. Excellent communication between the photographer and the couple and between the photographer and the other vendors is important and can ensure the wedding day runs as smoothly as possible.

Venue

Most of the time, the bride and groom have put a great deal of thought into the location of their wedding. I think that it is just as important to capture photographs of the setting as it is to photograph the actual events. The venue detail will give the event a sense of place. It will often make the viewer remember what it felt like to be at the wedding.

I try to arrive early enough in the day so that I can photograph the setting before I ever see the bride. I photograph the spot that they have chosen for their bridal preparations, the location of the ceremony, and (time permitting and if it is close by) the location of the reception. Not only does this give me a great opportunity to see how things are set up, but it also gives me a chance to photograph the buildings and some of the details that are a part of the setting. I also take this opportunity to scope out some locations for photographs if I haven't already done so—while I am photographing, I poke around the grounds, looking for hidden nooks and interesting spots, conscious of how the light is going to change.

Scouting the venue also gives you a great opportunity to interact with the other vendors. The florist may be decorating, the coordinator will probably be running around the venue, the band may be setting up. If you are there before the event begins it will give you a great opportunity to chat with some of the other vendors and to hear about any last-minute changes to the schedule or anything else that may be important for your coverage of the event.

TOP If I can, I try to photograph the reception site before the ceremony. If the decorations are set up, then early in the day is a great time to photograph the details before the guests come in and disturb them.

ABOVE There are beautiful details all over the venue if you aren't afraid to ask where to find them. This was shot at $f/2.8$ and $1/50$ with my 85mm 1.4.

ABOVE When you photograph the venue before the ceremony begins, you will be seeing the spot at its best. This was photographed at *f*/2.8 with my 35mm lens.

BELOW It can be nice to photograph the ceremony site at the beginning of the day. It also gives you the chance to look at the setup and the lighting.

Preparations

Bridal preparations are usually a flurry of activity—hair, makeup, dresses, bridesmaids and relatives running to and fro. Emotions are running high. You tend to see it all during the bridal preparations, from nervousness to excitement and everything in between, and you can often capture some fantastic photographs of the interaction between the bride and her mother and the bride and her bridesmaids during this time.

ABOVE The bride, her mom and her maid of honor share a quiet moment before the ceremony starts. I photographed this with my 35mm lens at ƒ/2.2.

Makeup application and hair tend to take a long time, and though I take some photographs of both of these things, I don't photograph them nonstop. I ask the bride what time she is planning to put on her dress and then I arrive about a half hour before that time. That usually gives me ample opportunity to photograph the end of hair and makeup and to take many of the detail shots of the room. If I don't have a second photographer working with me, I often float between bride prep and groom prep until the bride is ready to put on her dress. My general policy is to start photographing the bride getting dressed as soon as she is completely covered, but I usually ask what the bride wants as she may want some photographs in her lingerie as she is stepping into the dress.

For the most part, during bridal prep I am trying to capture the interaction between the bride and her closest friends and family—I look for special moments shared between the bride and her best friends, I look for the hug that the mother gives the bride, or the look on the bride's father's face when he sees her in the dress for the first time. Many brides and bridesmaids will do a toast before they leave for the ceremony, and this is often an emotional impromptu speech made by the bride's best friends.

The bride has usually put a lot of thought into the bridal details, and I try to capture as many of them as I can. I always try to photograph the dress hanging up during the bridal preparations. I also photograph some of the other bridal details—her jewelry, her shoes, an elaborate lace border on the edge of the bride's veil, the bride's engagement ring—all the details that add to the bride and groom's wedding story.

I also take this opportunity to look for other things that may be important to the couple. Signs that they put up to direct their guests to the wedding, flip flops that have been left at the door that say "Bride" on the sole, the note in the flowers that the groom has sent to the bride that morning—I try to capture all of these things in the setting where they have been left. Upon seeing these images after the wedding, couples will often remark that those scenes made them remember what they were thinking or feeling the morning of the wedding or they will remind them of something funny that happened.

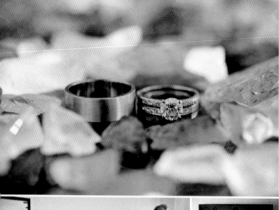

LEFT I will usually have a few minutes before the ceremony to grab a ring shot with my 60mm macro. I try to photograph the rings against a backdrop of their details—in this case, the bride and groom had sea glass scattered around their ceremony and reception site.

ABOVE LEFT If a bride has a long veil or a long train, you can usually catch a bridesmaid fixing it. The veil will usually come off after the ceremony and the dress with be bustled, so it's always a nice idea to get a shot of the veil fix prior to the ceremony.

ABOVE CENTER I try to get a shot of the dress hanging up before the bride puts it on. I wanted to add some light to this room, so I opened the curtains and the door to my left to let a nice, soft light fall on the dress.

ABOVE RIGHT Some brides have details within details. This bride had a very special rosary wrapped around her bouquet for the ceremony, so I wanted to be sure to get a shot of it. Because I photographed it in the bride's hands, I was also able to get a shot of her ring and beautiful nails.

After photographing the bride's dress going on, I try to pop over to catch up with the groom. While bridal preparations are similar from wedding to wedding, the groom's preparations are often vastly different. Most grooms do not spend anywhere near the amount of time getting ready that the brides do, so they fill their time with various activities. Some grooms will go golfing, some go to a bar, some sleep, but we always try to photograph them doing whatever it is that they choose to do on the morning of the wedding. Our cameras are time-synchronized, and most brides will get a kick out of looking at the proofs and being able to see that while she was applying her makeup her groom was watching cartoons and drinking a beer.

The First Look

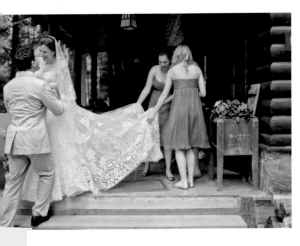

LEFT This couple had a Jewish ceremony, so they chose to see each other well before the wedding so that they could sign the Ketubah and take all of the formal family photographs. We planned the first look right outside the cabin where she was getting ready.

Many couples are choosing to see each other before the ceremony. Whether they have decided to see each other for personal reasons or for ceremonial reasons (at a Jewish wedding the bride and groom will see each other before the large wedding ceremony to sign the Ketubah), it is fun to set up a first look for the bride and groom. At most ceremonies, the groom sees the bride for the first time when she walks down the aisle. However, at that time they are in the middle of the ceremony and it usually isn't the proper time for the groom to sweep the bride in his arms and tell her how beautiful she looks and for the bride to give the groom a quick kiss and tell him how excited she is that they are getting married. In other words, when the bride and groom see each other for the first time during a ceremony, they are not sharing an intimate moment.

If you set up a first look, you can capture the intimacy of that first moment. It gives them the time to react to one another and to tell each other how they are feeling and to hug and kiss prior to the start of the ceremony. Not all brides and grooms want to do one (some still stand by the superstition that the groom shouldn't see the bride prior to the start of the ceremony), but those that do are giving you a great opportunity to capture some intimate moments between the bride and groom. I often choose a longer lens and try to maintain some space between me and the couple to give them the feeling of "privacy."

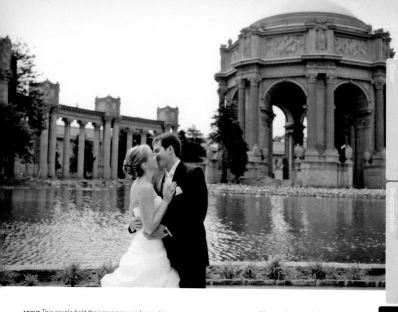

ABOVE This couple held their ceremony and reception outside of San Francisco, but they wanted to get some shots in the city. Because we didn't have time to get back into the city between the ceremony and reception, they planned a first look so that we could take photographs in San Francisco prior to the ceremony.

BELOW LEFT TO RIGHT I love to photograph the look on the groom's face as he sees the bride for the first time in her dress.

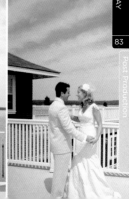

Ceremonies

I have photographed ceremonies in all kinds of places—from a white sandy beach at high noon to a candlelit hall with low ceilings, and everything in between. I like to know all the details about the ceremony location and how it is going to be lit well before the wedding day because it will affect which lenses I choose to photograph the ceremony and what equipment I bring with me. Most of the time I shoot with a combination of my 35mm $f/2$ and my 85mm $f/1.4$. For the majority of the ceremonies that I photograph, the 85mm provides me with sufficient reach. However, if I am working with a large ceremony or if I have limited mobility (some churches have strict rules about the movement of the photographer and the locations from which they can shoot) I will occasionally use my 180mm 2.8 to give me some extra reach and flexibility.

If the ceremony is inside, I also like to have a general layout of the church or building. Sometimes there are balconies or doors to the side of the altar, and I like to make sure that I know how to get to them and if they are going to be unlocked. In churches that do not have a center aisle, I need to make sure I know whether the bride will be walking up the left or the right side, and I like to choose an alternate vantage point (other than the center aisle) for the exchange or rings and the kiss.

If the ceremony is outside, I will usually have more flexibility and mobility. If there is strong backlighting I may need to use a little fill flash to lift the shadows in the faces (although this is not something that I do often—I only break it out in the harshest of conditions). For the most part I use existing light and a longer lens (my 85mm) for most

BELOW Occasionally the bride and groom will plan an interesting exit from the church. This was shot at 1/125 of a second because I wanted some motion blur from the rice.

of the ceremony, interspersed with my fisheye lens to capture the entire ceremony location. I like the long zoom on Aperture Priority, wide open or close to it, because it allows me to stand at a good distance from the bride and groom and to separate them from the background effectively.

There are so many different types of ceremonies—from civil ceremonies to religious ceremonies and ceremonies that combine elements of each or elements of different religions. In addition, couples often try to put their own personal stamp on the ceremony with special readings, traditions and music. There are also many different types of ceremony locations—from a dark hall lit by candlelight to a bright beach at high noon. I always try to have a clear understanding of the details of the ceremony itself—the length, the schedule, the special events, who is going to be involved and where

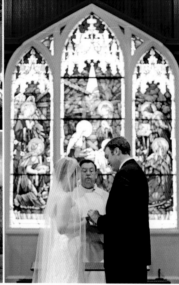

they are going to stand—in addition to the details of the ceremony location and lighting.

I usually arrive about ten minutes before the bride arrives, and I use that opportunity to take some test exposures, to photograph the interaction of the guests, and to photograph some of the details of the ceremony (flowers, candles and other decorations). When the processional starts and the mothers are walked down the aisle, I position myself at the front of the aisle (to the side, usually crouched down) so that I can photograph the mothers, the bridesmaids and the bride coming up the aisle. From this vantage point I am also able to swivel quickly and photograph the groom's face as the bride comes up the aisle. If I have a second photographer with me, I will position him at the back of the ceremony so that he can photograph the back of the bride's dress with everyone swiveling to look at her.

CLOCKWISE FROM TOP LEFT

I try to take a fisheye shot at every ceremony to capture the entire ceremony site. This was taken with my Nikon 10.5mm lens at ƒ/2.8.

Many churches have stained-glass windows backlighting the couple, mixed with uneven tungsten lighting on the other side. Be sure to manually adjust your exposure to keep from underexposing the photograph. This was shot with the 85mm 1.4 at ƒ/2.5 to keep the priest in focus while throwing the window out of focus.

It can be a very special moment when the bride walks to the ceremony site with her dad, brother, mom, or whoever is walking her down the aisle. I try to capture those moments prior to the start of the ceremony.

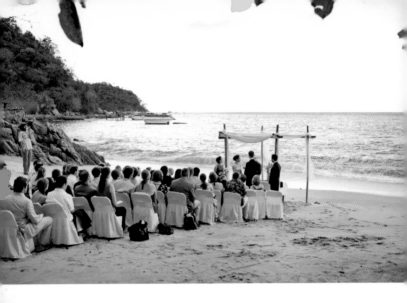

After the processional, I head to the back of the ceremony. I like to use the balcony to shoot down on the ceremony and to take some wide-angle shots of the entire room, and I also like to roam from side to side, remaining as unobtrusive as possible while I capture the expressions on the faces of the bride and groom as well as their parents in the front row of the ceremony.

The time immediately following the ceremony is one of my favorite times to photograph during the wedding day. The bride and groom (and their family and friends) are often very emotional immediately after the ceremony. Often the bride and groom will take a few moments by themselves. I like to capture these photographs from afar—a tender touch on the cheek, a tearful hug, a series of unbelieving smiles and laughs. I like to photograph these moments with a longer lens to give them the feeling of privacy. As

ABOVE I kept the leaves in the upper part of the photograph to frame the rest of the scene. They add some visual interest in what is an otherwise nondescript sky.

they are joined by their friends and family, I switch to a wider-angle (usually a 35mm or 24mm lens and sometimes even a fisheye), so that I can capture the group hugs or impromptu toasts.

Some couples choose to have a receiving line after the ceremony while some leave immediately to start the formal photographs, and still others stage interesting exits from their ceremony site. If the bride and groom are doing a receiving line, this is a great opportunity to photograph candid shots of the bride and groom being congratulated by individual guests. I usually photograph these

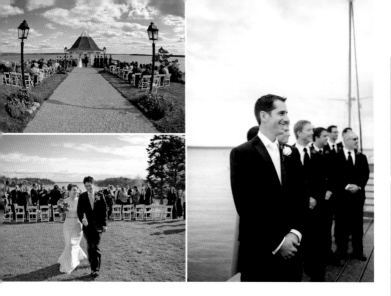

TOP I photographed this with my fisheye at ƒ/3.5 so that I could capture all of the guests as well as the bright blue sky.

ABOVE As the bride and groom walk down the aisle I try to back up with them—sometimes the best expressions come after they pass their guests and then turn to one another.

ABOVE When the bride starts walking down the aisle I always turn to capture the look on the groom's face. This was shot with my 35mm at ƒ/2.8 because I didn't want them to be in sharp focus but I still wanted to see the expressions on their faces.

with a longer lens so I can maintain some distance, and I alternate between positioning myself behind the bride and groom to capture the faces of the guests, and positioning myself in front of the bride and groom to capture their faces. Sometimes the bride and groom will stage an exit and will exit the church or building while the guests throw flower petals or rice or blow bubbles—if they do this I like to switch to a wider-angle lens (a 35mm or a 24mm lens) so that I can capture the bride and groom as well as those around them in the act of throwing rice.

Sometimes the bride and groom have

hired interesting transportation for the day—horse-drawn carriages, trolleys, antique cars and limos. I like to swing out into the road (carefully, of course) to photograph the car in the foreground and the ceremony site and guests in the background. I like to use a wide-angle to capture this photograph so that I can fill the frame with both elements.

Formals

ABOVE We were lucky enough to have some nice, soft light falling on the bride and groom and their family members. We chose to stay at the ceremony site for this photograph which was convenient for most of the family.

I try to have a few different locations chosen for the formals ahead of time—the first for the formal family and wedding-party shots and the rest for the fun bridal-party shots. For the family formals I try to find a comfortable, accessible location with good light. By good light, I mean that I look for a spot where the light that falls on the subject is flattering. If it is overcast or you are in open shade, a good technique for finding good light is to have your assistant turn in a circle while you watch how the light falls on them from every direction. If you don't have an assistant, this is easily accomplished by holding up your arm and seeing how the light falls on your hand and forearm. Notice that as you turn in place the light will change—sometimes it will produce unflattering shadows and sometimes it will fall evenly in a flattering way.

I usually want to find a spot out of the direct sun (especially if it is in the middle of the day in the summer), and that is accessible for people with canes and wheelchairs. I try to choose a location that will be good for expressions rather than one that will be good for capturing the view. For me it is more important to capture family formals in which the family members are not squinting or sweating profusely in the direct sunlight. If there is no good, shady spot around or if the bride and the groom really have their hearts set on taking the formals in a certain location, I may need to add some fill flash to the formals.

If I need to photograph the group in the direct sun, then I try to put the sun to their backs and slightly off to one side. If the sun is directly behind them then I may lose contrast or pick up some unwanted lens flare. The farther to the side I place the group in relation to the sun, the better my odds are for remaining flare-free. And while I love flare in some creative shots of the couple, I definitely don't want a lot of flare in my formals. Once I have the location picked out, I do a test exposure for the background. I am trying to determine the settings for retaining the bright blue sky or the reflection on the water without blowing the highlights. I usually have to stop down quite a bit so that I can stay under my flash sync speed of 1/250 of a second. Often I find myself shooting at $f/11$ so that I can stay within that range; while I know that I have high-speed sync enabled and could choose to shoot at a larger aperture if I so desired, I choose to remain within my maximum sync speed because I will be taking a lot of images in quick succession and I want my flash to fire and recycle as fast as possible. I put my flash on the camera or hold it to the side with a cord (or have an assistant hold it off to the side with a wireless trigger, although I choose this scenario) and set it to Manual. You will usually have to point it directly at the group so that you can balance the flash with the extremely bright light behind them. When I use my Nikon speedlights, I usually find myself setting my flash (on Manual) at 1/1 or at 1/2. Occasionally I will use my flash off-camera and have an

ABOVE LEFT It is also a nice idea to take some detail photographs during the family formals, as is the case with this bride and her parents. Some photographers do their family formals off of a list supplied by the bride and groom, and this works really well for a lot of wedding photographers out there. I do not usually photograph formals from a list; rather, I do a set number and combination of family photographs that usually covers everything that the couple wants. I do it this way because the order in which we do the photographs minimizes the amount of time that we need to do the photographs. Essentially, what I do is start with a big photograph and then ask people to step out of the photograph so we are breaking down to smaller groups.

assistant hold it on the side (connected to my camera with a flash sync cord or with my Pocket Wizards), but since I don't work with an assistant very often and I dial my flash to the minimum setting needed to fill the shadows, I will usually leave it on my camera because I am doing just a few of these shots.

I can't stress enough that it is important to know about any divorces in the family prior to the start of the family formals. Imagine a scenario in which the parents of the groom are divorced. You will need to know whether the bride and groom want to treat the divorced family as one big family (all of the parents together, even if they are remarried) or whether the couple wants to treat the divorced family as two separate families. Occasionally, the couple will choose to treat it as three separate families (the groom's biological parents, the groom's mom and her family, the groom's dad and his family).

With a typical family I will take the following photographs in this order:

ABOVE RIGHT It was an overcast day in a shady spot, so I needed to add some fill flash to these family photographs. I shot at 1/250 at ƒ/4.5 and added a flash in Manual on low power to brighten the shadows on the faces.

1. **Bride and Groom and Bride's Extended Family.** I position the bride and groom in the center of the photograph with parents and siblings next to the bride and groom. I ask everyone else to fill in.

2. **Bride and Groom and Bride's Immediate Family.** I simply ask the extended family to step out of the previous shot. I already have the immediate family in position.

3. **Bride and Groom and Bride's Parents.** I ask the siblings to step out of the previous shot.

4. **Bride and Bride's Parents.** I ask the groom to step out of the shot.

5. **Bride and Bride's Mom.** I ask Dad to step out of the shot.

6. **Bride and Bride's Dad.** I ask Mom to step out and Dad to step back in.

7. **Bride and Siblings.** I ask the siblings to step in again.

8. **Bride and Grandparents.** If the grandparents are infirm or mobility impaired then I may do this shot first so that the grandparents can go and sit down or I may postpone this shot until later in the reception.

Wedding Party

THE PHOTOBOOTH

ABOVE The bride and groom brought props for the photobooth, and we used them for some fun shots with the groomsmen.

I have never run across a bridal party that is excited to take photographs. Most of them have been to weddings where they do a lot of standing around and waiting after the wedding, and usually after the ceremony they are settling themselves in for the long haul of formal photographs with grim determination. I try to change all that in the first few minutes of working with a bridal party; I want to keep everyone happy while capturing meaningful photographs of the people most important to the bride and groom.

First, I start with a very simple standard photograph of the bridal party. This is the one that they are expecting. Personally, I like to break up the sexes, so I will ask everyone to find the person that they walked out with. This will quickly separate them into guy/girl pairs. If they have an uneven number or a mixed wedding party (men that stood up for the bride, or women that stood up for the groom) then I will just quickly sort them myself. I place half of them on one side of the bride and groom and half on the other side. If I have a group with radically different heights I may shuffle people around.

It is important to observe the details—they may not be that noticeable while you are working with the group, but you will definitely see them in the photographs. Make sure that jackets are straight, sunglasses are off and that the hands don't look awkward. The women are simple to adjust because they usually have bouquets to hold and I will just make sure that they are holding them at approximately the same level. Most of the time I will ask the men to put their hands in their pants pockets—this will give the group a more relaxed look while doing something with awkward-looking hands. If anyone is standing straight on to the camera, I simply ask them to turn in slightly to the bride and groom while putting their weight on their back foot—this makes them unlock their knees and will be a much more flattering position. This whole process (from the line-up to the photograph) takes no more than three minutes, and then we quickly move on.

POSING THE WEDDING PARTY

TOP | I try to take a standard photograph of the wedding party lined up. I like to alternate the bridesmaids and the groomsmen to balance the color on both sides.

LEFT | I like staggering the wedding party during the formal photographs. They usually do not expect it and it can be something that they have fun with. I photographed this at ƒ/4.0 to keep the edges of my frame in focus.

BELOW LEFT If you don't have any interesting natural elements on which to stagger the wedding party, stairs will help to add some height and depth to the photograph.

Next, I want to make sure that I get them to move around. Most of the time I have them toward me while they are lined up—I simply ask them not to look at me, but rather to look at one another while talking. Occasionally they ask for a jumping shot, and while it is not standard, I am happy to comply—it all depends on the personality of the group as a whole. Once they have loosened up, I move right into the environmental portrait, which is usually everyone's favorite shot. To do this, I use elements of the venue or of the environment itself—rocks on the beach, a wall, stairs—and I stagger members of the wedding party. Everyone has something different to do—stand, sit or lean. This is easier in some locations and more difficult in others, but I try to do one of these photographs (time permitting, of course) at almost every wedding.

Finally, I will usually split them up into two groups—the bridesmaids and the groomsmen. I will give one of them a break while I work with the other group. Once again,

ABOVE After I took the standard photograph of the wedding party lined up, I staggered them with some sitting, some standing, and some leaning against the rock wall. I like symmetry in my photographs so I will usually try to balance out the sides.

I try not to take more than five minutes with each group so that there is a minimum of standing around. I will quickly do a shot of them lined up together and then, if we have extra time, I will try to do something more creative using selective focus or staggered posing. While I have them separated into groups, I will usually take a quick shot of the bride with each of her bridesmaids individually and the groom with each of his groomsmen individually. Make sure that you keep shooting, because after the "formal" shot is taken, a very real moment (a hug between bridesmaids and the bride, a congratulatory "high five" between the groom and the groomsmen) will occur.

If the bride and groom have fun props or accessories for their wedding, I will try to integrate them into one of the group

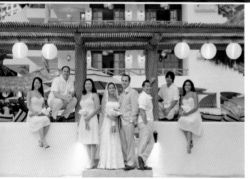

ABOVE This wedding party was excited to do the jumping shot, so I planned it as a beautiful silhouette against the sunset. I underexposed the sky to create the silhouette.

LEFT A wall can be a great place to stagger the wedding party. Even if you don't have a lot of options for positioning, simply turning their bodies so that they are back-to-back with someone rather than front-to-back can make a big difference.

photographs. Sometimes they bring props for the Photobooth, and those are fun to grab and use for the wedding party. Each wedding party is different, and I take the personality of the group into account when I decide how silly we will get with the wedding-party shots.

Choosing Different Locations for the Bride and Groom Portraits

ABOVE LEFT I was drawn to the two red doors on opposite sides of the building, so I separated the bride and groom for this photograph.

ABOVE RIGHT I like using fun signs when they give a sense of place. This couple was married right down the road, and this sign was an obvious first stop for us.

Have you ever arrived at a wedding or a photo shoot and had someone run up to you and say "I know the perfect place for pictures" or "this is where other photographers take their photographs"? Sometimes the photo location they suggest will be okay, but usually it is not what I am looking for—my clients don't hire me to have photographs that look like every other photographer's who has ever shot at the venue. Thank them for their advice, and if the couple is really excited about that location take one or two shots there, but don't be afraid to do your own thing, too.

I have photographed next to dumpsters, in abandoned buildings and at subway stations. I have photographed weddings at beautiful venues and taken the bride and groom around back to photograph them in the alley. I explain to my clients during the consultation stage that the best locations for photographs may not always be the most obvious ones. They trust me because of the confidence I have in the locations that I choose. Blaze your own path, and do it with confidence.

What do I look for in a location? I look for good light first and foremost. By good light, I

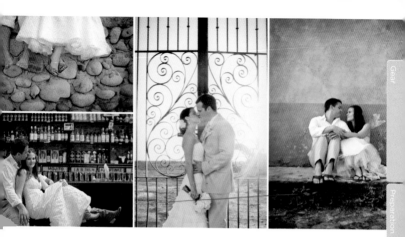

TOP LEFT The wall is visually interesting and provides a great backdrop for the shoes and the bare feet of the groom.

ABOVE Sometimes the most interesting photographs can be made in unexpected places. We took a break from the hot sun to spend a minute inside, and we made this photograph in front of the colorful bar.

CENTER Even though this gate is a few blocks away from the hotel district (and right behind a trash heap) I love the look of it.

ABOVE RIGHT I love bright colors. The peeling paint was an added bonus when I spotted this wall.

mean that I look for a spot where the light that falls on the couple is flattering. A good technique for "finding" good light is to have your assistant (if you have one) turn in a circle while you watch how the light falls on them from every direction. If you don't have an assistant, this is easily accomplished by holding up your arm and seeing how the light falls on your hand and forearm.

Second, I look for a variety of backdrops that add visual interest to the scene. The obvious backdrops are those that comprise the environmental portraits—the portraits of the bride and groom that showcase the venue or the location of the wedding, such as the ocean in the background or the mountains in the distance. Some of my favorite locations, however, are the less obvious ones—a colorful wall, an alley with a metal fire-escape,

an abandoned building or an overgrown field.

Third, I try to photograph the couple in this combination of good light and interesting location from a variety of vantage points. Sometimes the photograph that I envision and execute is made much better by changing my perspective or my lens—by dropping to the ground to minimize the background and emphasize the sky, by including something (like the grass) in the foreground, or by tilting my camera to make a more interesting composition.

Whenever I think I have found the perfect location, I try to look at it from different angles, with different lenses, and from different directions. Often my favorite photograph at a particular location will not be the one that I originally envisioned, but rather one that I "discovered" in the course of the shoot.

Bride and Groom

Most of our couples come to us wanting something a little different—elegant environmental portraiture rather than a series of them looking at the camera and smiling. However, while the couple may want to veer in a different direction, I try to remain cognizant of the fact that their parents and grandparents will likely want the shot of the couple looking at the camera and smiling. So, as soon as I am finished with the wedding-party shots (and I dismiss them to the cocktail hour so that they won't pose a distraction to the bride and groom), I will set up the bride and groom in this standard portrait. Generally I have them form a "V" so that they are slightly facing each other while also facing the camera. The bride will usually be holding a bouquet, so pay attention to what the groom is doing with his hands. Some grooms don't have any idea what to do with their hands—they will put one arm around the bride, but they leave the other hand awkwardly floating out in space. Give them something to do with that hand. You can have them put it in their pants pocket for a casually elegant feel. If you want a more traditional portrait, have the groom put one arm around the bride's back and bring the other hand up to hold the bouquet with the bride to center it between them. If they are very comfortable together from the beginning then I will have them press their cheeks together (or, if there is a significant height difference I will just have them "snuggle in together"). Generally the bride and groom are at their stiffest at the beginning of our short session together, so I give more direction for this first shot and less direction as they loosen up and start having fun.

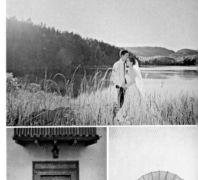

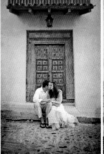

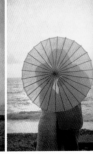

TOP Generally I am photographing wide open (or close to it), but I stopped down to $f/8$ here so that I could include some flare in the shot.

ABOVE LEFT This is one of my favorite photographs of the past year. The yellow wall, the door to frame the couple, and the cobblestone street all come together to create a beautiful frame for the couple.

ABOVE RIGHT The bride brought a parasol to her beach wedding, so I used it to create a silhouette with the strong backlighting.

OPPOSITE I love photographing in the rain. If rain is in the forecast, talk to your couple about bringing an umbrella and some rain boots for some fun photographs out of doors.

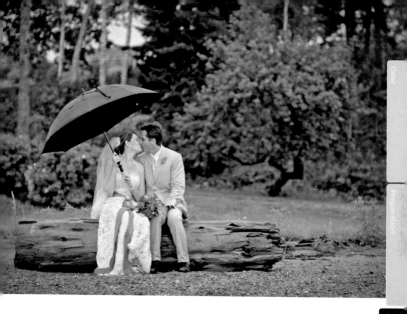

Pose one goes directly into pose two—I ask the bride to drop her flowers on the ground, and go chest-to-chest with the groom. She puts both of her arms around the groom and he puts both of his arms around her (like they are giving each other a hug) and then they turn their heads to look at the camera. Pay attention to the arms of the bride here—if the bride has an ill-fitting dress or if her arms are a bit bigger (or even if they are tiny but she has demonstrated at some point during the day that she is self-conscious) then make sure that the bride's arms are around the waist of the groom, in between his body and his arms, so that his arms are on the outside and appear bigger.

As I do for the rest of the day (except for the group photographs and the open dancing, when I am at $f/4$), I am shooting with a shallow depth of field. I am generally at an aperture of $f/2.2$ to $f/2.8$ for this series of

photographs. I usually photograph these first two poses with the same lens that I used for the family and wedding party (generally my 50mm or 35mm). Pay attention to the perspective of the lens—if you are shooting with a wider-angle (35mm or wider), make sure that you are far enough away from the bride and groom that you don't distort their bodies.

With the next shot, I like to demonstrate the "formal" poses are over and that we are going to start the fun shots. At this time I like to have the couple face each other and hold hands, leaving a bit of space between them. I will throw the fisheye on the camera, lie down between them, and have them lean in and kiss while I photograph them. It's a fun shot, and it is different from any other shot they will have of the two of them throughout the day.

While I am on the ground I will switch over to my 35mm or 50mm lens and take the

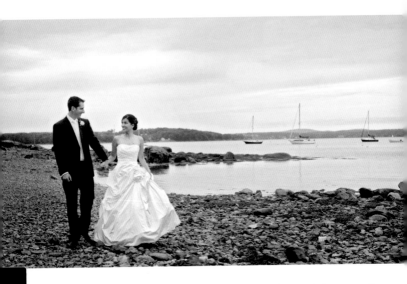

bride's bouquet and put it in front of me on the ground. Then I ask the bride and groom to walk hand-in-hand away from the camera, capturing the bouquet in the foreground and the couple in the background. Because I am shooting wide open (or close to it), the couple will be pleasantly out of focus in the background. After I have one or two shots of the bouquet with the couple as a backdrop, I stand up, put my 85mm 1.4 on the camera, and photograph them walking together (which they are still doing from the last shot). I tell them at the beginning of the stroll to take it slow, so the slow speed usually gives them a lot of time to look at each other and chat while they are walking. At some point I will have them stop and kiss (providing me with a great opportunity for an environmental portrait), and then start walking back towards the camera. If you have a very camera-aware

couple, you may have to ask them not to give you the "deer-in-headlights look," but rather to talk to and look at each other.

When we reach this point, about five to ten minutes have elapsed since we started the bride-and-groom photographs. I assess (prior to the wedding day and then again on the wedding day itself) how much time they want to spend taking photographs, and with some of my couples we might have time for one good environmental shot and that will be it—if this is the case, then I choose my favorite backdrop and set them up (see the environmental portrait section for more details). If I feel that we can take our time, then we will gradually hit a few different locations that provide interesting backdrops and I will play around with my lens choice, perspective and posing options.

There are times when the end of the

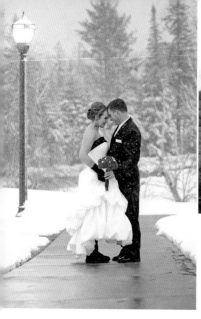

LEFT Uggs and a daring bride and groom can make for a fun photograph on a snowy day. It was fairly dark when we went outside, so I photographed this at ISO 3200.

ABOVE This beautiful couple had a significant height difference and he was rounding his back to lean closer to her when they were chest to chest. To create a more relaxed-looking portrait, I simply had her turn around and lean into him instead.

OPPOSITE This couple was so easy to photograph—I asked them to take a walk on the beach together after their wedding and they joked and laughed together the entire time.

ceremony and the time alloted for the formal photographs will not coincide with the best light. This is especially true of daytime or late-morning ceremonies—if it is a sunny day, you may have a bride and groom that are squinting at each other. I always know what the sunset time is, and if it is really bright I will either suggest that they go and enjoy the cocktail hour and that we get together again for five minutes of photographs before they are announced into dinner, or (if sunset is still a long way off) that they enjoy cocktail hour and dinner and that we sneak away for a few minutes after they are finished with their meal. The bride and groom usually eat first, so they will be finished with their meal before the rest of the guests and they won't even be missed at that point. Be sure to talk to your coordinator or event planner prior to scheduling anything like that, though, as you

may be cutting into a special event like cake cutting or speeches. However, if you can make it work, it is a fabulous idea to photograph the bride and groom in the golden light just prior to and during sunset. Of course, it will also give you a great opportunity to take some sunset shots as well.

During the consultation stage, many of my couples ask, "What if it rains?" It is good to talk about the possibility before the day. I am able to convince most of my couples that photographing in the rain and in the cold can be fun, and most will choose to do some photographs outside, even in a downpour or in the snow.

Large Group Shots

A lot of my couples want a nice group photograph of all of their guests. I love taking this shot, but it is important to know your location well before you promise this shot to the bride and groom. It is imperative that you have the right location, since you will either need to stagger the group (by using steps or something that gives you different levels) or by getting up high and shooting down on the guests. If you are shooting down on them from a few stories in the air, then you don't have to worry about positioning as much—everyone will be looking up at you, so no one will be hidden. I ask the bride and groom to stand in front, and then everyone else crowds around and looks up.

If you are staggering the group and shooting them from the same level or below, it is important to pay more attention to the positioning. There are always some people who will try to stand behind others—I try to tell the group that no one should be behind anyone else unless they are on a different step. You will also need to be aware that some of the older folks in the group may not be able to navigate stairs well, so you should encourage them to stay near the bottom row.

BELOW I knew that once we got to the reception there would be no space to take a group photograph, so we set it up outside the church as people filed out.

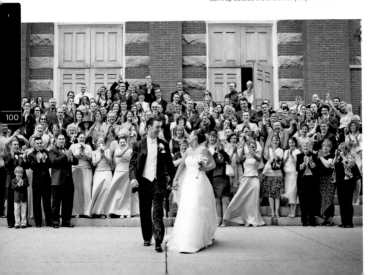

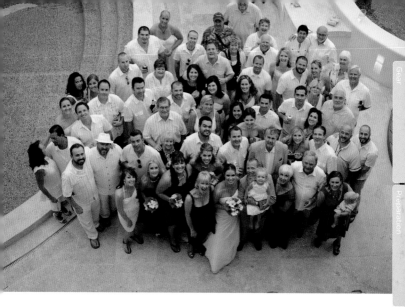

ABOVE AND BELOW I love photographing groups from balconies, because the view with a wide lens allows me to get the entire group in, and often the scenery as well.

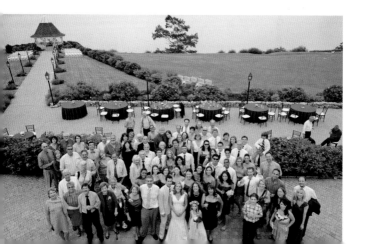

The Cocktail Hour

During the cocktail hour I like to throw a longer lens on my camera so that I can take photographs of guests having a good time without having them camera-aware. I like my 180mm lens for the cocktail hour because it lets me stand far enough away to be able to capture real moments between the guests and the bride and groom. The vast majority of my couples do not have a receiving line after their ceremony, so the cocktail hour is going to be full of congratulatory hugs and happy greetings. Although I like to follow the bride and groom and capture candid moments, I also pay attention to the family and wedding-party members. Other than the bride and groom (who usually spread themselves out to greet everyone), I have found that people gravitate towards those they know best during the cocktail hour. Therefore, you can generally catch mom with her lifelong friends or dad with his cousin who moved to Alaska—I like to keep a second camera body with me with a 35mm lens attached so that I can easily photograph a grip-and-grin shot of these groups.

Cocktail hour is also a great time to capture the bride and groom with some of their informal groups—if they want a photograph with their friends, or family from across the country, this is a nice time to capture that. I generally tell the bride and groom to work the cocktail hour and visit everyone, but to wave me over when ready and we will take the photograph at that point. That way the bride and groom feel that they can relax and that the "formal" photographs are over, but we are also taking advantage of some of the "free" time they have to take some of those extra photographs that are important to them.

OPPOSITE LEFT At some point during the cocktail hour the bride and groom made their entrance. The light wasn't falling into the stairwell, so I added a touch of fill-flash bounce behind me to lessen the shadows on their faces.

OPPOSITE RIGHT I like to take a few photographs of the entire cocktail-hour area—at this wedding, the cocktail hour was in a different location from the rest of the party, and I wanted to be sure to document it.

TOP Occasionally the bride and groom will have lawn games for their guests to play during the cocktail hour. Stalk the course and wait for the bride and groom to take part and you will have a fun photograph.

ABOVE If the cocktail hour is outside watch for beautiful skies and capture a wide shot of the party.

LEFT This photograph of the bride and groom being announced at the end of the cocktail hour is one of my favorite photographs of the two of them. I love their expressions.

BELOW LEFT Sometimes the bride and groom will have a special tent for the cocktail hour and will set it up as a lounge. I like to sneak in there before the guests are invited in, to photograph the setup.

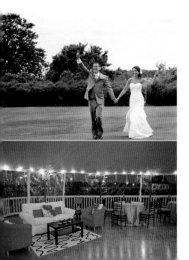

103

Reception Details

The reception is usually the result of many months, sometimes years, of planning. The flowers, the silver, the covers on the chairs, the flowers on the tables, the band, the place cards, the food itself—the reception is full of details that the bride and groom have spent a long time on as the wedding day approached, and I try to capture as much of it as I can. I want the bride and groom to look at the photographs and remember not only who was there, but also what kind of music was playing. A mariachi group? A harpist? A nine-piece brass band? Also, what kind of food they ate, what their tables looked like, and what the room looked like as a whole.

I try to photograph many of these images as early in the day as possible—tables never look quite as good once the guests have started eating, and most couples are going to want a photograph of their cake before they cut into it.

If you are photographing the ceremony and reception at one location, it is sometimes possible to photograph the reception details prior to the start of the ceremony. I like to check with the florist and the coordinator to see when they plan to have the room (or tent) ready, and if it is hours before the ceremony I will arrive early to photograph the details while they are fresh. If not, then at some point during the cocktail hour I will try to sneak away and photograph the reception details before the guests enter the room or the tent.

Look for the things that will be moved or might disappear and start there. I typically start by photographing the table assignments as those cards (or favors) will move as soon as the guests enter the room. Next I take a wide-angle photograph of the entire room. I try to do this without flash so that the ambient light and the "feel" of the room are maintained. This is also a good time to document the centerpieces and the cake (if it is out), as well as any children's favors, interesting bar setups, chandeliers (or any special lighting), or lounges. More brides are providing baskets of flip flops for their female guests to change into once they start dancing—these are fun and the colors usually match the wedding colors.

LEFT If there are special lights above the tables, I photograph the centerpieces from a perspective that makes it possible to include those lights overhead. In this case, I photographed this table with my 35mm.

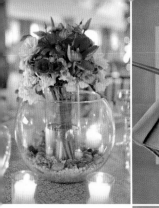

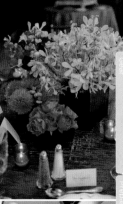

CLOCKWISE FROM ABOVE

When I photograph the centerpieces, I try to wait until the candles are lit so that they produce a nice glow around the edges of the frame.

Don't forget the menus and napkins when you are photographing detail shots. These were too pretty to miss.

I wanted to photograph the gorgeous cake in the background of this shot, so I positioned myself at just the right angle and height.

I try to take a wide-angle shot of the dinner area in addition to all of the details. I want the bride and groom to remember what it felt like to walk into that room.

If there is a band I like to photograph them to help set the scene of the reception.

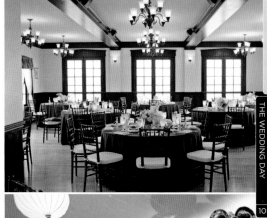
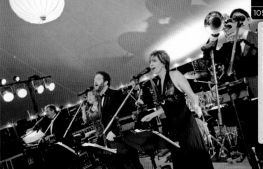

Food

At the very least, I like to photograph the appetizers that are passed around at the cocktail hour, since the appetizers usually have the best presentation and lend themselves well to a tantalizing photograph. They are also the easiest to photograph, as the waiters aren't rushing about to serve the tables, but are strolling casually through the cocktail venue. I ask the waiters to hold the tray down and away from their bodies and I use my 35mm or my 60mm macro. Try to approach the waiters as they exit the kitchen area, so that you can catch the appetizer tray while it is full.

If the caterer's presentation is particularly good or if I have a good relationship with the event manager, I may also try to take a photograph of the different courses right before they go out to the guests. It is usually a hectic time in the kitchen, but if the caterer knows that you can create great photographs of the food they may be willing to pass the food by you before they serve it.

After the meal, look for any special dessert or coffee stations. Many couples are opting for a dessert bar in addition to (or

ABOVE LEFT I asked the waiter to hold this tray down so that I could get in close to this beautiful presentation with my 35mm lens.

ABOVE RIGHT A waiter brought this tray out for the bride and groom while we were doing the formal photographs, and I grabbed this shot of it before the wedding party dived in.

instead of) a cake. Some weddings will even have snack stations near the end of the night—one of my weddings this year had a hot-dog stand, another had a cappuccino bar with pastries, and a third had a taco stand. These all afford a fabulous opportunity to document the more fun side of the food.

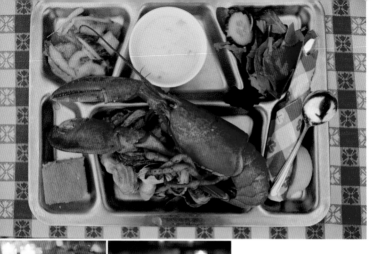

ABOVE I shot this photograph from above because the checkered tablecloth complemented the lobster bake nicely.

LEFT When the couple creates a dessert bar, I like to photograph each individual treat with the glow of the ambient light surrounding them.

BELOW LEFT Shot from the side, this beautiful gazpacho looked like a blob of red and hid the presentation. Therefore, I stood on a chair and shot down so that I could see inside the glass and behind the glass to the flowers behind.

BELOW RIGHT This beautiful appetizer was being prepared on a table in the kitchen that wasn't aesthetically pleasing, so I got close enough to the plate to fill the frame with it and avoid including any of the background.

CHILDREN AND PETS

Being a mom of two, I in no way confuse my big furry Akita with my two rambunctious boys, but when photographing any of the three I employ the same strategies. Both are fantastic subjects for photographs at weddings, and both can move quickly or react unexpectedly (especially if they see the camera pointed in their direction). First, I try to photograph them quickly. Patience is not usually high on the list of attributes of either child or furry friend, and both tend to tire out and make a quick exit from the reception.

Second, I like to know their role in the day. Are the children walking down the aisle? Are the pets? On a particularly happy occasion, the children walked the dog down the aisle and it became one of my favorite photographs of the day. I try to be prepared for a number of scenarios and will station my second shooter (if I have one) accordingly in case things do not go as planned.

Third, I assess the personality of the child (or pet) before I choose my lens. If I am working with a particularly shy or rambunctious subject, then I will choose my long lens (usually my 180mm) so that I can photograph them from afar. If the subject is easy-going, then I feel more comfortable getting in closer to them and will choose my 35mm or my 50mm lens.

I watch the expressions of the children as the day progresses—their faces usually show exactly what they are thinking if you don't interrupt them. I try to capture the excitement on the face of the flower girl as she puts on the pretty dress that she has waited so long to wear. I try to capture the

BELOW This little girl kept walking closer and closer to me as I was photographing the girls, so I encouraged her to come even closer, dropped down to her level, and photographed her with the bridesmaids framing her.

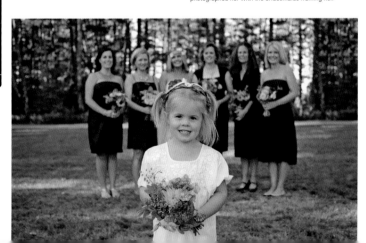

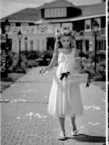
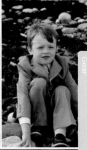

CLOCKWISE FROM TOP LEFT

The bride and groom brought their dog as their ringbearer. I captured him in a few shots before the ceremony in case he didn't make it beyond the first few minutes.

This little boy loved the camera and kept turning around to strike a pose.

This beautiful flower girl was very methodical with her placement of the flowers. I love the look of concentration on her face as she tries to distribute them evenly.

I photographed a series of this little boy as he patiently waited for us to finish with the formal photographs.

This little boy was a dancer—every time a song came on that he liked he would take the floor and breakdance.

look of boredom on the face of the ring bearer during the long, hot ceremony. I try to capture the dance floor, as the children are the first ones out there dancing.

If there are any members of the bridal party or immediate family of the bride and groom that have children in attendance, I always try to take a quick photograph of their family. After all, it is not often that the young children are dressed up and everyone is together, and they usually appreciate it and will purchase the photograph later.

It is important to remember if there are young children in the wedding party that you may not have time to compose the perfect shot. If I am setting up a formal photograph I will usually add a small child last, as they do not normally have the patience to wait while other people are being shuffled around. There will be times when the children cannot wait to be photographed, and there are also times when they will be crying. I do not try to force a photograph with a child—if the bride really wants a photograph with the flower girl and the flower girl is crying, I try to convince the bride to save the photograph until after the child has taken a rest.

A really great strategy I have developed for working with children during formals is to involve them in the process. They have been told what to do all day, and sometimes letting them make a decision or giving them a task can really make the experience a fun one.

Speeches

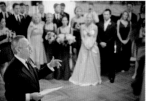
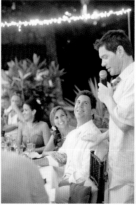
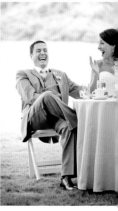
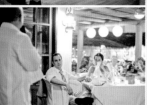

This is one of my favorite parts of the reception because emotions are running high—I have never seen a series of speeches that didn't produce laughs, tears, smiles, or fantastic looks between the bride and groom. The people giving the speeches are almost always the people who are most important to the couple, so it is a good opportunity to get some great shots of them. And, finally, everybody (most of the time, at least) is stationary, so I find it incredibly easy to take photographs, even in the darkest of venues.

I try to capture three things during the speeches: the speaker; the bride and groom reacting to the speech; and other guests reacting to the speech. I try to do mostly available-light photographs during the speeches (using a combination of my 85mm 1.4 and my 180mm 2.8), although I will add a touch of flash (dragging the shutter to bring up the ambient light) if the faces are in

TOP LEFT I stood on some stairs to get high enough so that I could fill the background behind the father of the groom with the couple and his other daughters.

BELOW LEFT This beautiful bride cried during her dad's speech. I wanted to capture her emotion with her dad framing her in the foreground so when she looks at the photographs in the years to come she will remember what prompted her tears.

CENTER I framed the groom's reaction with his brother. I wanted the brother to be slightly out of focus, so I shot this with my 50mm lens at $f/2$.

ABOVE RIGHT The groom reacts to his best man's speech. In order to capture the bride and groom as well as the speaker, I had to stand quite far away. Therefore, I chose my 180mm lens to capture the reactions of the bride and groom while I used my 50mm lens on my other camera to photograph the best man.

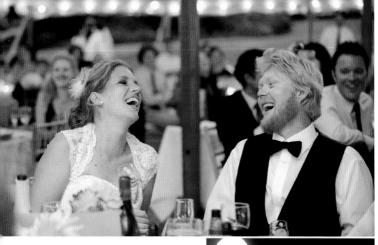

ABOVE This couple laughed during so many of the toasts, so I positioned myself to capture their reactions.

shadow or if the reception is very dark.

If I have a second shooter, I will position him or her in a good location to photograph the speaker while I photograph the bride and groom's reactions. This is a great opportunity to capture a series—there will often be wonderful and different expressions in quick succession, and you can capture the spirit of the speech by photographing the changing expressions.

Sometimes it is impossible to get both the speaker and the bride and groom in the same photograph based on where the speaker is standing. However, I always try to get at least one series of photographs in which they are all in the same frame. If they are facing one another, then I may frame the bride and groom with the speaker's out-of-focus side, or frame the speaker in the space in between the bride's and groom's heads to make a more dynamic photograph.

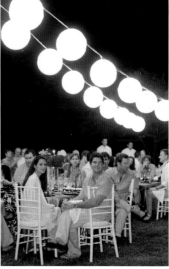

ABOVE The speeches gave me a great opportunity to capture these tables and the lights strung above because everyone is turning in their seats to watch the speaker.

The First Dance

Whether the bride and groom have choreographed their first dance or whether they are just winging it, you can produce some beautiful photographs of their first dance. I like to photograph this part of the reception with a very shallow depth of field so that the bride and groom are in sharp focus while you can see the crowd standing around observing, pleasantly out of focus. I like to photograph this part of the reception without flash, but if I need to add flash I like to balance the ambient light with the light coming from the flash (usually bounced behind me, to one side or the other). In general, I like to photograph the first dance with my 35mm or 50mm, because then I can see what else is going on in the frame of the photograph—I like to see the expressions of the parents while the couple is on the dance floor, and often I will catch a tear or two rolling down someone's cheek.

Be sure to chat with your couple about the first dance before it happens, as the couple will sometimes have a surprise up their sleeves. On two occasions in the past year my couples have started elegantly enough but then stopped mid-song to stage a fun and rambunctious dance-off. On other occasions they have changed their outfits and on others they have pulled their friends and families onto the dance floor to dance with them.

On one interesting occasion the first dance was a signal for the fire-juggling act to begin, and on still another they had a fireworks display in the middle of their dance. The bridal blogs and magazines are all encouraging brides and grooms to highlight their individuality throughout the day to really make the wedding day their own, and

BELOW I used my 28mm 1.4 to photograph this first dance at *f*/2. I wanted a slightly wider angle than I normally use for the first dance because the guests were crowded in so close.

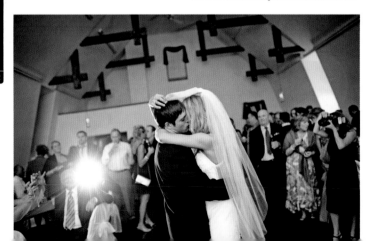

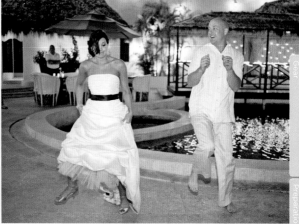

ANTICLOCKWISE FROM TOP LEFT

The bride and groom were dancing under the stars in this open-air reception, so I bounced my flash directly off of the wall to my right in order to lift the shadows on their faces and illuminate the guests behind them.

I wanted to photograph the lights above the bride and the groom without including all of their guests in the background, so I crouched low to the ground to take this shot. It was shot at 1/40 of a second to bring up the glow in the lanterns.

The lights behind the couple create a beautiful background for their first dance. Even though there were lights on the other side of them (behind me) as well, they were farther away and didn't create the nice, soft yellow glow. Therefore, I chose to photograph the bride and groom at this particular angle.

The bride and groom broke out into a dance-off part way through the first dance. I changed my shutter speed to a faster setting to accommodate the faster dancing.

brides and grooms are coming up with some fabulous ways to do just that during the first dance. The more you know about the upcoming events, the better.

At most receptions there will also be two other formal dances—the bride will dance with her father and the groom will dance with his mother. Most of the time they will do so to two separate songs, but sometimes they will dance to the same song. If one of the parents is deceased, the bride and groom will sometimes invite all of the remaining parents onto the dance floor for a group dance or a grandparent will stand in. I love it when they include both parents in each set—in this scenario the bride dances with her dad and the groom asks the mother of the bride to dance (and vice versa when the groom dances with his mom). There are many different variations, so I always try to find out from the couple what they are planning to do. I try to look at the guests that are around the dance floor while these dances are happening so that I can capture the expressions of the onlookers. For example, if the bride is dancing with her father, I will try to capture them in focus in the foreground while the bride's mom watches from the edge of the floor.

Cutting the Cake

Whether the couple has chosen a simple cake, an elaborate cake or even cupcakes, I always photograph it at some point during the reception before the bride and groom cut the cake. I like to photograph it earlier in the evening so that I can photograph it with ambient light (many receptions tend to get darker as they progress), but there are times when the cake isn't displayed until right before the cake-cutting. Pay attention to the details on the cake—some cakes are designed to match the color-scheme of the wedding, some have elaborate patterns of icing to match the flowers or the design, and some will be elaborately decorated and done up with custom cake-toppers that have been made to look like the bride and groom or reflect their individual interests.

You never know what kind of cake-cutting you are going to get. I have had the most reserved couples chase each other around the reception with the cake and the most rowdy couples gently feed each other at the same time. While most of my couples fall within the latter group, I am prepared for either scenario. The cake-cutting is a great opportunity to capture some of the other important players at the wedding—you can get a great shot of

the mother of the bride smiling at the bride and groom in the background of the photograph if you angle yourself properly. It is also fun to capture all of the other cameras that are at the reception. Most of the guests will congregate with their own cameras to take photographs of the bride and groom cutting the cake and I love to swing around to the other side of the bride and groom to photograph the bride and groom in the foreground with all of the cameras in the background.

BELOW LEFT While I loved the lighting on the band for the majority of this reception, I found it rather distracting during the cake-cutting. Therefore I shot vertical and had my couple fill most of the frame to cut down on the distraction.

CENTER I love when the bride and groom have artistic cakes. This one matched their wedding perfectly.

BELOW I always keep the camera to my eye, even after I think the cake-cutting is over. I'm glad I did, because the bride did this after they fed each other nicely.

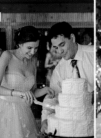

ABOVE I loved the candlelight and the overhead light illuminating this gorgeous dessert table, so I shot this at 6400 and 1/50 of a second at $f/2.2$ to capture this photograph without flash.

LEFT By the time the bride and groom were ready to cut the cake, the reception room was quite dark as they prepared for open dancing. I bounced my flash off of the wall directly to my left to lift the shadows on their faces.

Other Events

I always check with the bride and groom to see whether they have any other events planned for the reception. At many Jewish wedding receptions, for example, they will dance the hora. At some Mexican weddings, the guests pin money on the bride's and groom's clothes while they are dancing. Some of my more free-spirited couples will buck tradition entirely and avoid the scheduled events altogether, making it imperative that you keep a lookout for natural interactions between the bride and the groom and their families and friends

BELOW The bride and groom put their own spin on this garter toss by tossing it from the second-floor balcony.

(which you should be doing anyway, but of course there is more pressure to photograph the bride and her dad sharing a candid moment when they choose to forgo the father–daughter dance). Although less common now, some brides and grooms still opt to do a bouquet and garter toss. Some couples choose to honor the couples married for decades with an anniversary dance—this will give you a great opportunity (perhaps one of the only opportunities if it isn't a slow-dancing sort of crowd) to photograph all of the couples dancing together).

I have seen many other special events as well—karaoke performed by some of the guests, a lip sync performed by the bridesmaids, fire-juggling, belly dancing,

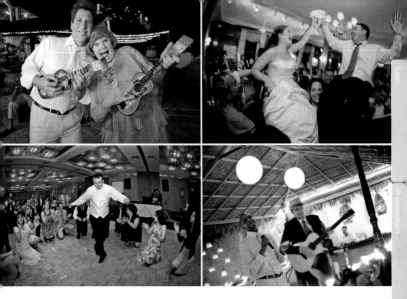

fireworks, poems that the bride and groom read for their parents—really, there is no limit to the special events that may happen during the reception. Most of these special events are planned, but some are impromptu. If I am taking a break to eat I try to remain in earshot of the reception so that I can hear any last-minute special events. It is always a good idea to get off on the right foot with the DJ or MC, as they will usually be the one who is asked to coordinate any changes to the schedule and they will alert you if you ask. The maid of honor and the best man are also good resources, as is the event planner or coordinator—these people are usually in the thick of anything being plotted for the reception.

CLOCKWISE FROM TOP LEFT

The fabulous coordinators at this wedding brought out a box of props mid-reception. Here is the groom sharing a moment with his mom. The flash is bounced off of the wall to my left.

I shot this at 1/30 of a second at 2.8 with my fisheye. Because the reception was dark, I was able to stop-motion with my flash and bring up the ambient light by dragging my shutter.

The groom's step brother and his good friend serenaded the bride and groom during the reception. I shot this at 1/80 of a second at ƒ/2.

The groom takes the floor during this Greek wedding. I shot this with my fisheye so that I could capture the groom and as many of the people surrounding him as possible.

Open Dancing

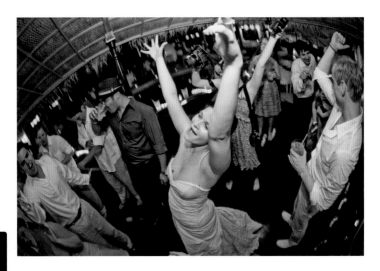

It is during the open dancing that I feel that I can capture the spirit of the reception. Some are loud, raucous affairs, while others are quiet and tame. I try to capture the spirit of both. First, I make sure that I photograph the musicians if they have chosen to hire a band. Second, I try to capture as many different guests dancing as we can—this is really the time that I feel I can capture the most guests in candid moments. Third, I always try to capture the parents of the bride and groom, the grandparents of the bride and groom, and the wedding party on the dance floor. Although I do try to capture everyone, I will spend more time focusing on these people during the reception.

If there is a balcony or stage of some sort

ABOVE I held my camera straight up over my head with my fisheye to capture this shot of the bride dancing.

in the reception room, I use it to get some elevation in order to shoot down on the reception. If not, I will often just walk around the dance floor with a wide-angle lens. I usually get right in the middle of the dancing, and although it means that I occasionally get jostled around, it also means that I am going to have a fabulous time because I am right in the action. My favorite lenses for open dancing are the 24mm 1.4 and my fisheye.

Make sure that you acquaint yourself with the focusing modes on your camera—the mode that you use throughout the day is sometimes not the best mode for tracking fast-moving subjects in the dark. All camera

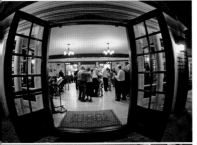

ABOVE LEFT This groomsman was playing to the camera, so I used my fisheye to get in really close. This was shot at 1/60 of a second at ƒ/3.2.

ABOVE RIGHT This was shot with my 14–24mm ƒ/2.8 at 19mm. You can see a bit of the distortion around the edges, but it doesn't bother me during open dancing. I like to shoot wide angles so that I can see the moment in the context of everything else that is happening.

LEFT If there is a wide door from the reception to the outside, it can be fun to photograph the outside of the venue at night with the dancing illuminated in the background.

BELOW LEFT The bride's cousins tied their ties together to form a makeshift limbo stick. I shot this at 1/50 of a second to bring up the ambient light in this dark room and used my flash bounced behind me to stop-motion.

models do it a bit differently (with different degrees of success, especially depending on the focusing speed of your lens), so really get to know your camera and lenses in the dark before you photograph the live action at a wedding.

I like to leave my flash off when I can, but as it gets darker I will add a camera on my hot shoe to bounce the flash. I don't like to bounce it straight up, since it produces flat lighting and under-eye shadows, but I will if that is my only option. Most of the time I prefer to bounce it behind me to one side or the other. For more dramatic lighting, I vary the angle and make it more pronounced (straight off to the side and bounced off of a wall directly to my left, for example). If I have a second shooter I may have him or her hold a second flash that is triggered by my flash or a Pocket Wizard—this will add more depth to the photograph by adding light from another direction. Rarely will I add a light on a stand or I will use a flash cord to take my flash off-camera, but I have seen fantastic pictures from photographers who utilize both of those methods. (See the section on Lighting a Room for more details.)

The Photobooth

I love the Photobooth. It is one of my favorite things to set up at a wedding, and it makes the editing process very entertaining. I don't have an actual booth; rather, I have a camera that is set on a tripod, with a diffused light, a remote shutter release and a screen for viewing. Basically, that means that a group steps in front of the camera (usually set up behind a screen for privacy and funnier photos), grabs the shutter-release mechanism (available for most camera models), lines themselves up in the screen, takes the shot, and then reviews the photo on the screen. It is a lot of fun, and will usually be a big draw for the fun-loving people who might not enjoy dancing.

Couples will often supply props (for example, sombreros, mustaches on sticks and fedoras), and the guests will rise to the challenge and create some funny setups. I love the Photobooth because of the opportunity it gives to capture grandma in a sombrero or a group of childhood friends in an uninhibited fashion, since they can always review and retake the photograph if they aren't happy with their expressions.

I like to set the camera up with a blank (preferably white) wall as the background, but if one isn't available I will sometimes bring a backdrop and stand with me so that the photographs will have a uniform background that is not distracting.

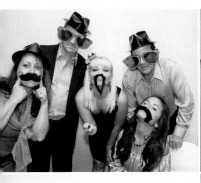

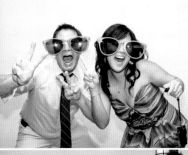

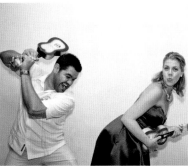

The Send-Off

Sometimes the bride and groom will organize an elaborate send-off, and sometimes the send-off will be a surprise gift from parents or friends. It might just be a special last dance or the decoration of the bride and groom's getaway car, or it might be something that requires more planning and effort. The most common special send-offs that I have photographed have involved vintage cars, fireworks and sparklers (thankfully, not all together).

The sparkler send-off is a fun way to photograph the bride and groom as they leave the reception—usually the guests have been lined up on either side with sparklers lighting the way as the bride and groom run through the aisle they have left between them. I like to photograph these with ambient light alone. I will use a touch of fill flash if the light from the sparklers isn't sufficient to bring up the shadows in the bride's and groom's faces.

Fireworks are a bit more tricky, because it can be difficult to try to get the bride and groom and the fireworks in the same frame. If possible, I try to have the bride and groom elevate themselves—stand on chairs or on a low wall while I crouch down or even lie on the ground and shoot up at them. See the section on photographing fireworks for more information.

If the bride and groom have a special last dance, this is usually a better time to photograph them than the first dance. They usually cuddle together and the guests are not afraid to crowd in even closer than they were during the first dance, and this gives me a chance to photograph the bride and groom in an embrace surrounded by their close family and friends.

I like to be creative when I light the getaway, and I have been known to use the headlights from one car to illuminate a sparkler exit or even the getaway car of the bride and groom. Video lights are also fabulous in this occasion because they produce a constant source of light and are easy to manipulate.

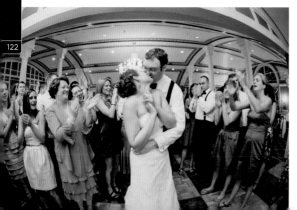

LEFT The bride and groom share a kiss as the last song of their reception ends. I shot this with my fisheye so that I could capture all of the friends and family surrounding them.

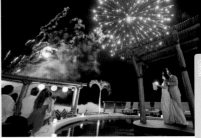

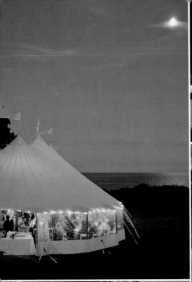

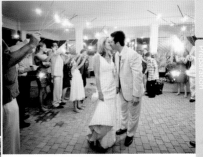

TOP LEFT I try to take one last shot of the venue at the end of the night. This photograph is one of my favorites because the moon is glinting off of the ocean behind the tent.

TOP RIGHT Fireworks are an amazing way to end a reception. This was shot with my 14mm at 1/25 of a second and 6400.

ABOVE The bride and groom leave the reception surrounded by sparklers. I used my flash to bring up the shadows on their faces.

LEFT The bride and groom were leaving in a vintage car—it was extremely dark, so I asked the people in the car behind them to pull up and turn on their headlights so that I could light them through the rear window.

REAL WEDDINGS
Wedding 1: Sasha and Sam

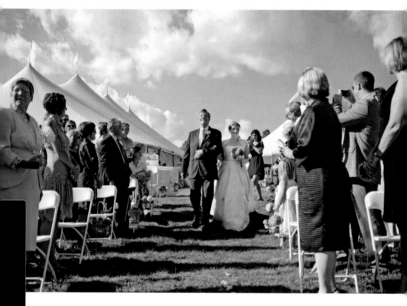

Sasha and Sam's unique wedding reflected their values and their style. Sasha and Sam are committed to the protection of the environment, and they wanted their wedding to be as green as possible while maintaining an elegant, comfortable feel. Many of the decorations at the Asticou (under a series of Sperry Tents) were antiques that were repurposed for the event, including the chandeliers and all the old bottles holding the flowers, and even the menus were made out of seeded paper so that they could be planted to produce wildflowers.

Amber Small (Sweetest Thing Events), the designer and coordinator, decorated this beautiful event with over 1000 dahlias that were grown locally. Because so much time and energy was put into finding and repurposing so many of the design elements and because each centerpiece was absolutely unique (all were completely different sizes and shapes with different types of dahlias, bottles and driftwood) it was essential to photograph all of the details.

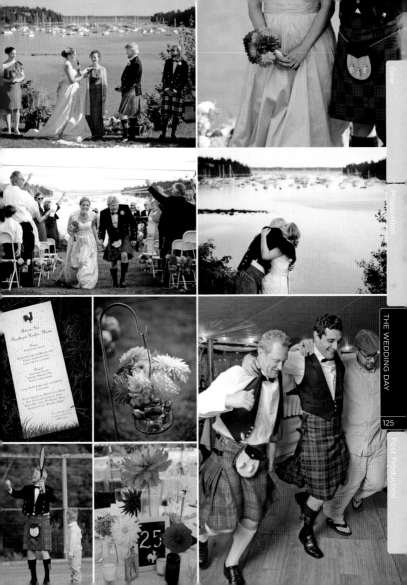

Wedding 2:
Abby and Colby

Abby and Colby had a picture-perfect wedding. They chose Point Lookout as their venue on a hilltop overlooking the coast of Maine. The classic design was provided by Christina Tonkin (of New York City), who was one of the set designers for the hit show *Sex And The City*.

Abby, who is starting her own wedding-detail company, spent a lot of time on all of the wonderful details, from the letterpress invitations to the personalized gift bags. The pine cones, I am told, were harvested from a tree that fell on one of the bridesmaid's cars, and were used as place-card holders on the tables. Abby and Colby also invited their dog to take part in the ceremony.

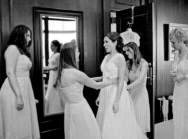

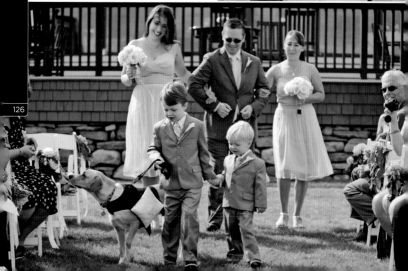

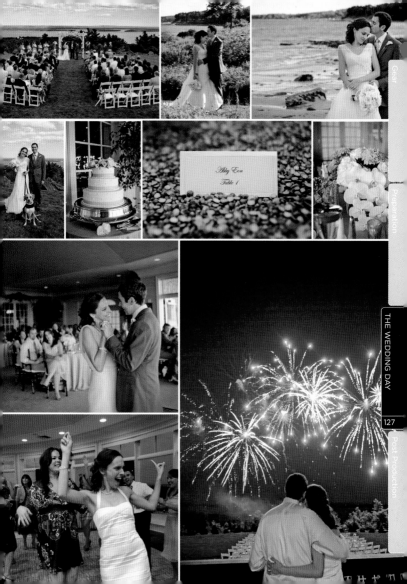

Wedding 3:
Erin and Damien

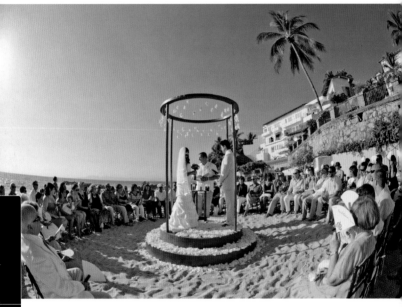

Erin and Damien were married on the beach in beautiful Conchas Chinas, Mexico, and they held their reception at Villa Celeste, a beautiful villa just steps away from the beach. They had one of the most unique ceremony concepts that I have ever seen—they wanted to surround themselves with their family and friends, so all the guests were placed in a circle around the bride and groom as they wed on a raised platform.

The coordination and design team (The Dazzling Details in Vallarta) executed this amazing design concept flawlessly. They even hung orchids up on the raised platform so that they danced in the wind above the couple during the ceremony. Even the lights at their open-air reception were designed to match the hanging orchids at the ceremony and on the top of the custom-built centerpieces.

jalama

Wedding 4:
Julia and Andrew

For their wedding, Julia and Andrew returned to Migis, the family summer camp where Julia spent her summers growing up. The location held a special significance for Julia, Andrew and their families, so it was important to document the location itself while creating beautiful environmental portraits of Julia and Andrew.

Julia and her mom put a great deal of time and thought into everything, from the custom invitations to the general design, so I spent extra time photographing the details. Because the reception was held in a room with low ceilings, beams and dark wood, it was necessary to bounce my flash creatively while my second and third shooters used room lights to augment their shots.

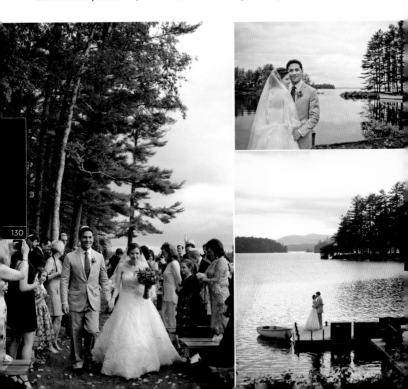

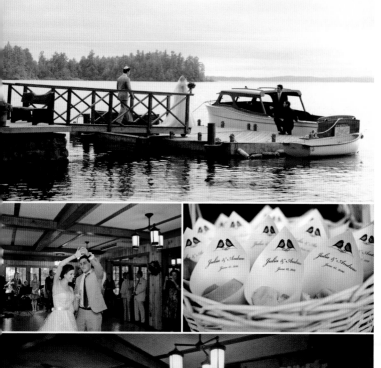

Wedding 5:
Jess and Jimmy

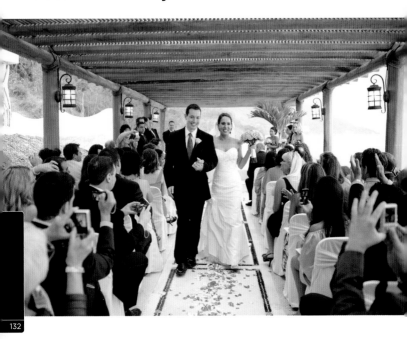

Jess and Jimmy were married at the gorgeous Playa Fiesta Hotel in Puerto Vallarta, Mexico. Jess and Jimmy wanted to incorporate bright colors and unique events into their wedding day, so Lindsay Burgess (the designer, coordinator, and owner) brought in fire jugglers as well as a Cuban band to spice up the event.

Because I knew that bright colors were important to Jess and Jimmy, I scouted some colorful locations nearby and photographed them with those colorful elements in the background to add a dash of pop to their photographs. I also wanted to make sure that I captured some of the environmental details, including the rocks on the beach. Jess and Jimmy also included the Photobooth in their coverage, which I (and they) loved.

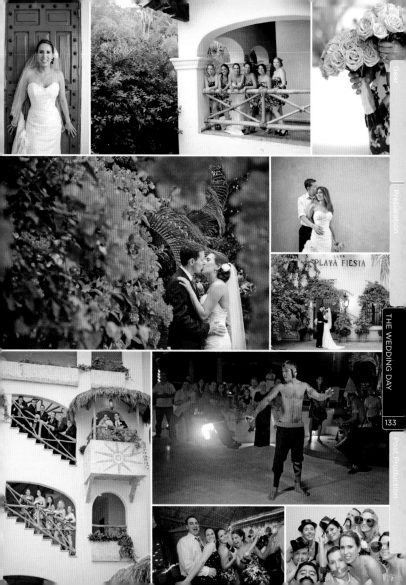

Wedding 6:
Sarah and Brandon

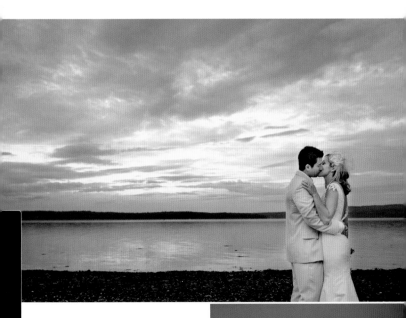

Sarah and Brandon were married on the Fourth of July, and so it was only fitting that they incorporate fireworks and sparklers into their wedding. The Retreat at French's Point, where they held their wedding, is a unique property on the coast of Maine and provided an amazing backdrop for some great environmental portraits.

Sarah and Brandon had a nautical theme, and Flora Fauna (the designer) used blue and yellow elements as well as driftwood antique bottles to pull everything together.

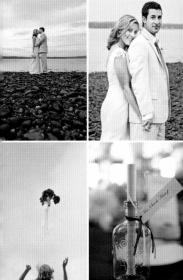
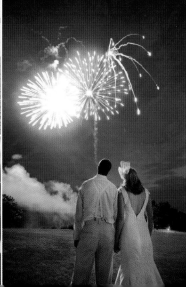

Wedding 7:
Megan and Brett

Megan wanted to celebrate her wedding to Brett at their family's home on the coast. With the help of Moxie Events and a custom tent from Sperry Seacoast she was able to make her dream a reality. The church ceremony was lovely and the couple and the bridal party arrived at the reception by boat.

The lighting was important to Megan and Brett, so they worked closely with Sperry to design the lighting concept for their wedding. The details and accents were very important to Megan and Brett, so I was given 30 minutes of time at the tent before any of the guests arrived at the reception.

TRASH THE DRESS

I love it when the bride and groom commission me to shoot a Day After session, popularly known as a "Trash the Dress" session. They get dressed up (often in the wedding dress and tux again), so they look beautiful together, but they do not have the pressures of the wedding day. There are no time constraints, reception details or guests to worry about. The day has come and gone, and they are completely relaxed. And, by this time, they are completely comfortable with me, and they aren't afraid to be openly affectionate with one another. The bride is also not afraid of getting the dress a little dirty—if she wants to keep it as an heirloom, though, I will recommend that she do a Day After location shoot or that she buy a different white dress to wear that might be a bit more disposable. The same goes for the groom.

For the Day After shoot, I either try to find different, interesting locations for our session or I may simply use locations from the day before that we didn't have time to get to. Sometimes the bride and groom are having their wedding in a coastal town, but not right on the beach, and there simply is not enough time to get there and get back to the reception in the timeframe that they have allotted. If this is the case, I will recommend a Day After session—we often drive to several different, interesting locations. My Day After sessions usually last about two hours, but have lasted much longer because I have so much fun doing them and the couple is usually having a great time as well. I feel like I can step outside of the box on the Day After sessions because of the lack of time pressure and "stay clean" pressure on me and the bride and groom.

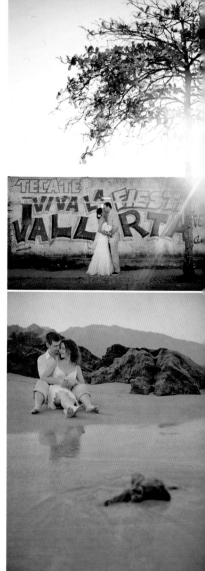

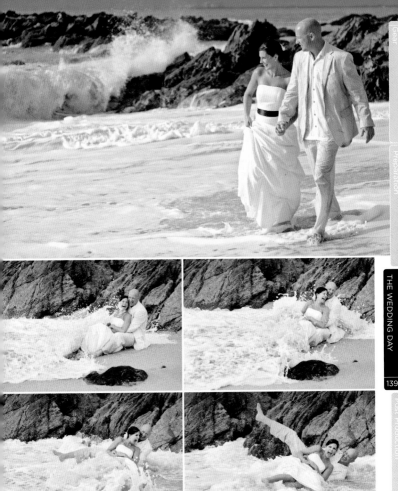

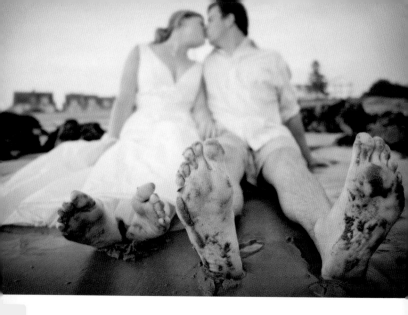

Although the beach is the most common request that I get for a Day After session, I have also done some fabulous Urban sessions as well—lots of back alleys and forgotten side streets, broken-down vehicles and deserted factories—I have even photographed one of these sessions in the back of an empty 18-wheel truck!

If the bride and groom want to get wet, then I will typically take them to a beach, lake or a river (or even a pool), and they will often end up completely immersed in the water. With the right couple this can be a tremendously fun experience and it will allow you to get some incredible shots of the two of them together. To get the bride and groom into the water during a Trash the Dress, I generally do three sets of shots. For the first, I start them off easy—usually by having them go for a walk on the beach. I have them get closer and closer to the waves until they are

walking in the water—this part of the shoot will give some of the fun expressions—especially if the water is cold.

For the second shot, I have the bride and groom sit on the water's edge. If we are at a beach, I have them sit in a position where the waves will get them wet. If we are at a river or a lake, I have them sit partially immersed in the water. I usually have the bride sit in between the groom's legs and lean into him with her back against his chest. Once again, I give them the same cuddling instructions that I gave them on the wedding day. Most of the time I can tell them just to cuddle and they will do it. If not, though, I tell the groom to kiss from temple down to shoulder on the bride, going slowly. This is one of my favorite shots, and if it is safe to do so (no huge current) I will often take this photo from the water, so that the water is in the foreground of the shot rushing up to the bride and

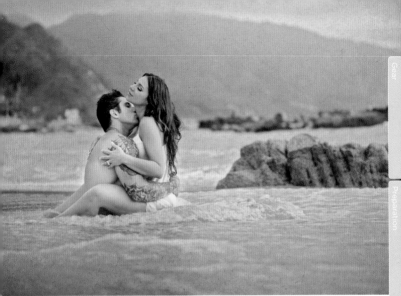

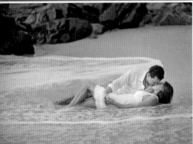

groom. Be aware of the waves behind you, though, and prepare to get wet.

For the third shot, I have the bride and groom lie on the beach, kissing. I try to set it up so that most of the waves will come up to the waist of the bride and groom—be prepared for the great expressions you will get if a bigger wave comes! If we are at a river or a lake, I will have them wade out into the water and kiss and cuddle in the water as the wedding dress swirls around the bride.

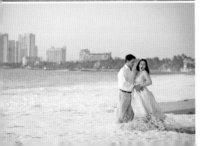

POST PRODUCTION

For good post production, organization is key. An efficient workflow and clear system is absolutely necessary—you never want to be in the position of having lost or saved over important work. If you can keep a critical eye to your work, image editing in post production can result in some truly breathtaking photographs.

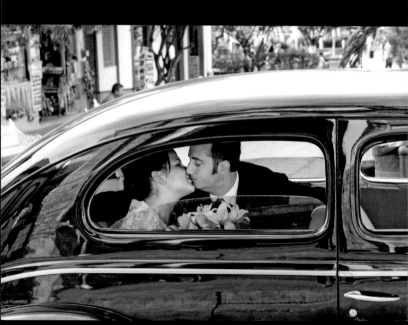

Workflow

You have finished shooting the wedding and now you have 3000 Raw images. How do you take those and sculpt them into polished photographs? Here is where the post-production phase of the wedding begins. In general, I spend almost as much time in post production (from backing up the images to the album design) as I do shooting the wedding itself.

It is essential to have a good system in place for handling your images after the wedding and taking them through to the delivery stage. Over the years I have tweaked the details of my workflow, but I am now down to these steps:

1. **Download wedding images immediately** to the Nexto digital storage device on my way home. You can set up the Nexto to automatically detect, copy and verify your memory card the second you insert it, so it is an incredibly quick and efficient way to bring all of the images into one place.

2. **Keep the memory cards off-site** (so that I have multiple copies of the images in different locations) and bring the Nexto device into the office to put the images onto my computer for editing.

3. **Back up the Raw images** to the client file on an external hard drive. The file is named in YYYYMMDDNameName format. For example, if Sara and Chris were married on December 31, 2010, their file name would be 20101231SaraChris. By naming the folder in this fashion I ensure that I can find the images by date or by name and that my storage devices will sort them in the order in which they were photographed.

4. **Import the images** into Lightroom applying my own preset. Create one-to-one previews.

5. **Create the blog post.** I choose a handful of detail photographs mixed with some of my favorite environmental portraits of the client as well as stand-out moments from the ceremony and reception. I export these images and retouch them in Photoshop and create a blog composite in Photoshop using actions that I created.

6. **Cull the images** in Lightroom.

7. **Lightly edit the images** in Lightroom.

8. **Export the images** as high-resolution jpegs.

9. **Combine the exported images** with the high-resolution blog edits and create the finished folder of images. Rename the images in Bridge.

LEFT The magic of the now-married couple kissing in the back of this beautiful vintage car is captured in black and white, giving the image a classic, timeless quality.

10. **Copy the folder to three hard drives** (one of which is stored off-site).

11. **Copy the folder to three DVDs** (one of which is stored off-site).

12. **Format the memory cards** used for the shoot and return them to the pool of cards.

13. **Upload the gallery** to my proofing and ordering website.

14. **Create a slideshow** or a proofing DVD if either are needed.

15. **Send the proofing** package to the clients and their parents.

16. **Submit the images** for publication (if desired).

By sticking to this workflow, I am able to ensure that I have followed each and every step. While it is very easy to remember posting the images to the blog, it is less easy for me to remember burning the right number of DVDs and sending one of them off-site. By checking off each step as I do it, I can relax knowing that the images are safe and that even if disaster strikes my home office or I suffer a hard-drive failure, the images are in more than one location. I used to have a big, dry erase board in my office and I would log all of my weddings on there, but now I have developed a checklist on Numbers for the iPad that allows me to see all of my tasks across every outstanding job at once.

ABOVE By focusing on the vibrantly-colored bouquet in the foreground, the couple is knocked back in this mirage-effect portrait creating an ethereal image.

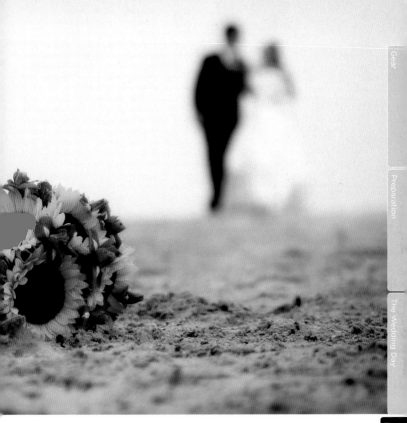

Importing, Sorting and Renaming in Lightroom

I use a Lightroom workflow for the majority of my post production. It is a fantastic tool for processing images—not only does it allow you to maintain and organize a large library of files, but it aso gives you the opportunity to process Raw files alongside jpeg files and make area-specific adjustments. In fact, only a handful of images ever make it into Photoshop (the blog images, the album images, any image ordered and images for publication), and I find that I can accomplish most of what I want to do for the majority of my images right in Lightroom.

First I import the folder of images into Lightroom. As I import the images I apply a custom preset (this setting is available in the import dialogue). I use a basic setting for the Nikon D3, D700 and D3S that I tweaked by adding a touch of contrast and vibrance (I will talk about Lightroom presets later). I ask Lightroom to render one-to-one previews as it imports the images (the setting is available in the import dialogue). When it comes to the editing stage, having these previews already generated will speed up my workflow exponentially. If you forget to do it on import, you can build the previews by selecting all of the images and going to Library>Previews>Render 1:1 Previews while you are in the Grid Mode (select Library on the upper right or press G).

When you are in Grid mode you can sort the images by Capture Time (in Grid mode, go to View>Sort>Capture Time). Prior to every shoot I sync the time of my cameras—over the course of a week they will stray from each other by a few seconds, and I want the ordering process in Lightroom to be seamless. If your cameras are lined up, then when you

ask Lightroom to sort your images by Capture Time it will display the images sequentially in the catalog. It is possible to change the time stamp on the images from one camera if you forget to sync your cameras prior to the shoot, but it is much simpler if you remember to do it up front. Once I have put the images in order, I rename them (from Grid mode go to Library>Rename Photos). I choose names that indicate that the images I am working with are the original images—usually something like SaraChrisOriginals0123.jpg. Because I always shoot in the thousands, I make sure that I choose a four-digit numbering scheme.

LIGHTROOM

OPPOSITE Adobe Lightroom makes it easy to create keyword batches or individual images on import. Go to the right side of the screen, open the "Apply During Import" dialogue, and type in your keywords.

Culling in Lightroom

Once I have imported and renamed my images I start the culling process. I used to cull and edit in one step, but I find that I have shaved hours off of my edit time by separating the two tasks. There are two basic styles of culling: editing out and editing in. I edit in (choose the keepers) for my portrait sessions and I edit out (ditch the rejects) for my weddings. I know other photographers who do it the other way around—find a style that works for you and stick to it.

To quickly edit out, go to Grid mode. Above the images you will see Attributes— click on it, and select the center flag. By doing that, Lightroom will only display the unflagged photos. That means that when you mark an image as a reject, it will disappear from the catalog (although it doesn't erase it, so you can always go back and unflag it). This is a nice feature because, if you reject a photo, it will disappear and Lightroom will auto-advance you to the next photo for consideration. It will also give you an accurate count of the images currently in your "keeper" pile. When I am editing out, I like to view the images full-screen, so I press the space bar to have the image fill the viewing area. If I want to keep it, I advance to the next photo with the right arrow key. If I want to reject the photo, I press X and the photo will disappear and the next photo will fill the screen. I can fly through the culling process in about 60 to 90 minutes. The temptation to fiddle with the images is there, of course, but I resist it in the name of streamlining my workflow.

If you choose to edit in, there are several ways that you can do it. For my portraits I assign a rating to an image. You can assign a color or a flag or a number of stars—I keep it simple. If I love an image and I want it to

appear in the gallery, I press 1 to give it one star. I scroll through the images using the right arrow key, pressing 1 when I see an image that makes the grade. Once I have gone through the entire galley, I tell Lightroom to only show me the images with one star, and everything other than the keepers will disappear.

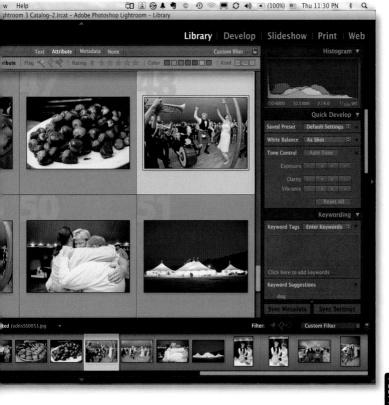

Library | Develop | Slideshow | Print | Web

In general, my edit is a lot tighter when I edit in. I will keep one- to two-hundred more photographs in the gallery when I edit out. While I want to be pickier about image selection for my portrait sessions, I am comfortable delivering a high number of images to my wedding clients and therefore choose to edit out. Your mileage may vary.

LIBRARY MODE

ABOVE I use the Library mode (pictured here) to edit in or edit out. To edit out (my preferred method for weddings), I mark the images with a "rejected" flag by pressing x.

Editing in Lightroom

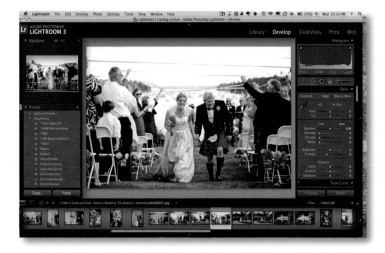

After I have narrowed my images into a keeper pile, I begin my edit process. I have used Adobe Lightroom since the very first Beta, so I am extremely quick and comfortable with the program. I used a tool the other day that shaved time off of my very efficient workflow, and if you find that you are less quick with Lightroom, then this tool will revolutionize your editing process. Called the RPG Keys, it is a small keyboard that plugs into your computer. Each of the keys is assigned a function—anything from adding or taking away contrast to split-toning the photograph. If your photograph needs a little boost in exposure, all it takes is a simple click of a button to give it that boost before you move on. Dependance on the sliders can be a thing of the past! I found the keyboard to

be intuitive and fun to use. You can even assign your favorite presets to some of the open buttons. I have three types of black-and-white conversions that I use, and each was assigned to a different button, allowing me to fly through those conversions. Simply put, the RPG Keys is a timesaver if you are editing your images in Lightroom.

I mentioned presets in the last paragraph, and I want to talk about that a bit more. Presets are an absolute must if you want to speed through your editing process. There are several presets available free of charge (simply do an internet search for Lightroom presets) and several that are available for purchase.

I make most of my own presets, but there are a few good ones that are commercially available. My favorite set comes from *Totally Rad Actions*—their set of Lightroom presets

RPG KEYS

LEFT The RPG keys will speed up your Lightroom workflow dramatically.

offers an entire workflow solution from a fully-automated, total-image adjuster to a series of smaller developing tweaks. They also offer several different presets to tone and finish your image. While I don't tone the majority of my images, I do find a few of the workflow presets to be incredible time savers and I really like one or two of the specialty presets.

If you like vintage tones, the LilyBlue preset set is excellent and offers a lot of flexibility. Kevin Kubota also offers several Lightroom presets, from the simple to the stylized—whatever your image style Kevin Kubota has something to match it. Leah Profancik also has a line of Lightroom presets that are designed to enhance color and add a golden glow to your photographs. I suggest that you look at some of the before-and-after photographs before

purchasing any presets—also look for examples on *Flickr* (often people will post before-and-afters and review presets and actions).

Tips and Tricks in Lightroom

Changing the Time Stamp: I shoot with the Nikon D3S, the Nikon D3 and the Nikon D700. As I mentioned earlier, it is very easy to sync the time between my cameras. However, I will occasionally work with a second photographer and sometimes we will forget to sync our cameras at the beginning of the shoot. If you import your images into Lightroom and you notice that one of your cameras is off, it is easy to change the time stamp of all of the images taken with that camera so that the images appear in the catalog in the proper order relative to the photographs taken with the other cameras. First, find a photograph from the out-of-sync camera and try to find a second photograph from the in-sync camera that was taken at almost the same moment. If I am working with a second photographer, then I look for the kiss picture during the ceremony, since it is likely that both of us captured it at the same moment.

If I am working alone, then I look at the processional. Look at the time stamp from both photographs (in the Library module, scroll all the way down on the right menu slider to look at your metadata). If my D3S has the kiss happening at 12:42:15 and my second shooter's 1D Mark IV has the kiss happening at 12:45:20, then I am going to change the time stamp on the Canon camera to reflect the same time as my D3S. The great thing about Lightroom is that it will change all of the other files from that camera by the same margin. Simply select all of the images taken with the 1D Mark IV (go to the Library module, click on the Metadata Tab over the grid, and choose the 1D Mark IV and then go to Edit>Select All). Make sure that the kiss photograph is the photograph that you see in the Navigator box, since this is the one that

you are going to change to a specific time. Select Metadata>Edit>Capture Time. Not only will Lightroom adjust the time stamp on that file, but it will also adjust every other selected photograph by the same amount of time.

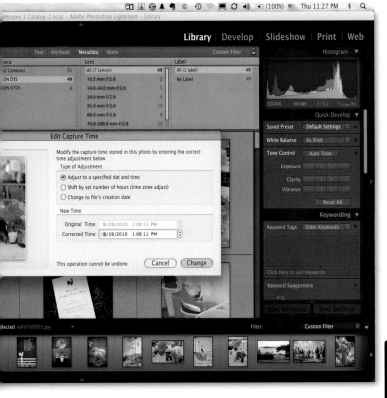

CHANGING THE TIME STAMP

ABOVE It is easy to change the time stamp of all of the images taken with one particular camera so that the images appear in the catalog in the proper order relative to the photographs taken with the other cameras.

Creating a Custom Black and White: Go to the Develop module and scroll down on the right menu slider until you see HSL/Color/B&W. Select B&W and your photograph will be converted to a black-and-white image. Lightroom will automatically select a grayscale mix that it thinks will work for your photograph, but you can play with the sliders to tweak that mix. I generally like to lift the skin tones, so I will move my red, orange and yellow sliders to the right. If there is a specific tone that you want to change, select the little circle to the left of Black and White Mix and click it onto a part of the photograph that you want to change. Click, hold and pull the mouse upward if you want to lift the tones, or click and hold and drag the mouse downward if you want to deepen the tones. Make sure you are looking at the entire photograph when you do this—all similar tones will also be affected to the same degree. When you are done, simply click the circle to the left of

Black and White Mix a second time. If you want to add some warmth to the shadows of your black and white, scroll below HSL/Color/B&W to Split Toning. Go to shadows and select a deep brown hue (35–37 on the hue slider is a good starting point) and add just a touch of saturation (I find that 10 is sufficient for adding just a touch of warmth).

Creating and Saving a Preset: Presets are so easy to make in Lightroom. If you find yourself doing the same tasks over and over again (for example, adding +10 contrast, +10 brightness and +20 vibrance to every photograph), or that you like a particular black-and-white mix that you have created, then make a preset for it to save you time. To make a preset, make the changes that you want to save to the preset to one of your photographs in the Develop module (to get there, click on Develop in the upper-right corner or simply press D) and then click on

the plus sign over the presets listed in the left column of the Develop module. A dialog box will come up asking you which changes you would like to save in the preset. Click on the applicable changes, name your preset and save it. For example, if I am saving a black-and-white preset, then I would want to click on Treatment (Black & White), Black and White Mix, Split Toning, and then press Create. Voila! Your preset will appear in the left column and you can even program it as one of your RPG keys.

Applying Presets in Batch: Now that I have created my Warm Black and White preset, I want to apply it to a batch of images. In the Library grid, select all of the photographs to which you want to apply the preset. Then go to the right menu slider and under Saved Preset, select Warm Black and White. Lightroom will apply those settings to all of the selected photographs.

CUSTOMIZING

ABOVE AND OPPOSITE Scroll down on the right side while in the Develop module until you see the HSL/Color/B&W section. By playing with the sliders, you can create a custom black and white.

Photoshop Essentials

With such a great Lightroom workflow, why would I ever use Photoshop? The answer is a simple one—I use the programs for very different things. Lightroom is my tool for processing Raw images, while Photoshop is my tool for enhancing a handful of my favorite images that have already been processed through Lightroom. They are programs that are used in tandem. While I color-correct and make density adjustments in Lightroom, I enhance colors, add overlays and make layer-specific changes in Photoshop (including dodging and burning, adding subtle vignettes, and fine-tuning my black-and-white images). Photoshop is a truly amazing application that provides virtually limitless flexibility when enhancing and customizing your images. There are some tools within the program that can help you to polish your images quickly and efficiently.

Actions: You can either make your own actions or purchase ready-made actions, but either way your actions will save you a lot of time by applying a number of adjustments to your images with one click of your mouse. To use Actions, simply open the image that you want to work on and click and play the action that you want to apply in the Action palette. I make a lot of my own actions, but I also buy and use pre-made actions. The actions that I use every day come from *Red Leaf Studios* (on my color images), Jeff Ascough (on my black-and-white images), and Kevin Kubota (I use Magic Sharp on every image that is printed through my studio). I also use a handflow of Workflow actions and black-and-white-toning actions from *Totally Rad Actions*. I use one or two toning actions from Jesh de Rox, mainly for working with sunset skies or images taken near dusk.

I also use actions to save time when I am creating albums and composites for my blog. I will mention Fundy's Album Builder in the section on albums (and it is a lifesaver). It is essentially a series of actions and scripts that allow me to lay out a custom album design quickly and efficiently. I have also created a set of eight actions that let me quickly create the image composites that appear on my blog. This one set of actions saves me hours of time every month.

Keystrokes: If you make certain adjustments in Photoshop over and over again, you can assign those adjustments a keystroke. For example, I like to use the Shadow/Highlight tool to open my shadows by about ten percent. Rather than clicking on Image>Adjustments>Shadow/Highlight every time I want to apply this to an image, I have assigned it a keystroke. To assign keystrokes to your most-used functions, go to Edit>Keyboard Shortcuts, navigate to the menu/adjustment that you want to open and then assign it a key. You will be amazed at how much time this will save you during the editing process.

Layers and Layer Masks: Layers are great tools because they let you apply changes to an image on a separate layer. This is great for two reasons. First, you don't have to apply the changes globally across the image. Instead, you can apply changes to a small part of the image by painting the effect in or out on the layer mask. Second, if you overdo the adjustments, you can simply lower the opacity of the layer to lessen the effect or you can choose to delete the layer altogether. I always apply any image changes that I make on a new layer. To create a new layer that is a copy of your image, select Layer>New>Layer Via Copy. With that layer selected, make any

LAYER MASK

ABOVE AND LEFT Using a layer mask allows you to quickly paint an effect in or out of an image.

changes that you want—play with curves, add contrast, or adjust the hue or saturation of the image. If you go too far, simply lower the opacity of the layer (the opacity slider is above and to the right of the layer bar).

One of the most powerful tools in Photoshop is the layer mask. Perhaps you like image enhancements, but the steps that have turned the grass a beautiful green have also made your bride look like she spent too much time with some orange self-tanner prior to

her wedding. Instead of lowering the opacity of the layer and diminishing the beautiful effect on the sky, you can choose to paint out the effect on her skin by adding a layer mask. To do so, click on the layer that you want to adjust in the layer bar and then click Add a Mask (the third tool from the left on the bottom of the Layer palette). The mask will show up as a solid white box next to the layer in the Layer tab. Make sure that white box is selected and then choose a soft, black paintbrush at 20 percent opacity. Paint on the image where you want to lessen the effect—it will gradually erase out the layer that you have selected. If you go too far, simply select a brush of the opposite color and paint the layer back in.

Dodging and Burning via Adjustment Layers

Almost every photograph can benefit from dodging and burning, and it can make a significant difference. I use dodging and burning to lighten the shadows on the faces of the bride and groom and to darken distractions in the photographs. You can also selectively burn along the figure of the bride to give her a slimmer appearance. You can also dodge certain areas of the photograph to draw attention to them.

Of course, Photoshop has the Dodge and Burn tools, but I choose to dodge and burn via adjustment layers in order to avoid the color shift that can sometimes happen when using the Dodge and Burn tools. I would suggest that you set up an action that creates these adjustment layers for you. That way, you can set up your photograph for dodging and burning in Photoshop with just one click. If you prefer the convenience of a ready-made action, there are several action sets that include actions that set up dodge and burn layers (one of the best is found in the *Totally Rad Action* set).

To dodge and burn via adjustment layers, follow this guide:

1. Layer>New Adjustment Layer>Curves (there is also a shortcut button for this on the bottom of the Layer tab).

2. Pick a spot in the center of the line and drag it up towards the upper-left corner. This will lighten the image considerably. It will look strange at this stage as it will apply the changes to the whole image.

3. You already have a layer mask for this

layer—it is white. However, I want to make it black because I want to paint the effect in, not vice versa. So, select the paint bucket in black, make sure the layer mask is selected (click on the white box next to your layer once) and click the paint bucket over the image. It will fill your layer mask with black, hiding the effect. Then, select a soft, white brush at about 20 percent opacity and paint back the effect in areas that you want lightened. The more you paint, the more you lighten the image.

4. Make sure the Background layer is selected in the Layer tab. Then click Layer>New Adjustment Layer>Curves.

5. Pick a spot in the center of the line and drag it down towards the lower-right corner. This will darken the image.

6. As in point 3, make your layer mask black and then paint in areas of the image with the white brush to darken the image.

7. Flatten the image (Layer>Flatten Image).

DODGING AND BURNING

ABOVE I use curves to dodge and burn my images. If you don't want to create your own action for this, *Totally Rad Actions* has a few wonderful dodge and burn actions.

Textures and Overlays

I love working with textures and overlays in Photoshop. I have found that the key is to keep it subtle—I try not to apply a texture across a sky or very bright area, or the texture will take over the photograph. I always brush the texture out of skin and clothing (using layer masks), and I try to match a texture or overlay with the mood of a particular photograph. This is definitely not a one-size-fits-all adjustment.

First, get out there and shoot some textures. Brick, pavement, rust or sand—they are all fabulous textures that can be used to enhance your photographs. You will save yourself a ton of money (and have a lot of fun) if you shoot your own textures. If you are struggling with that assignment (or if you simply don't have the time), there are several wonderful textures that are available. Jesh de Rox offers a series of textures that are fantastic. If you are looking for some vintage overlays, Red Leaf Studios has a set that is excellent. Totally Rad Actions also has a nice set (I will talk more about the textures from TRA in just a moment).

First, open two photographs—the image that you want to work on and the texture that you want to add. Either drag and drop or copy and paste the texture on the photo you want to adjust. Resize it and drag it around until it covers the entire image. Then go into the Layer palette and adjust the blending mode. Soft Light will usually give you the most subtle application of the texture. If you want something more noticeable, try Overlay or Hard Light. If you are working with vintage overlays (such as those from *Red Leaf Studios*) try Multiply. Then adjust the opacity to your liking. Add a layer mask and paint the effect

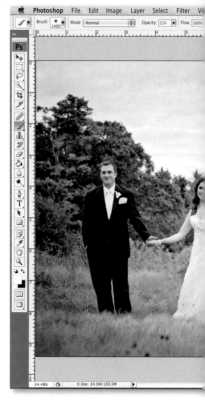

out of the more obvious areas, as well as the skin and clothing of the couple. Then readjust the layer opacity if needed. You may want to save a pre-texture version of your photograph and a flattened file with the texture applied, just in case you come back to the photograph an hour or two later and decide that you overdid it.

If you want a really cool system for adding textures to images, then check out Dirty Pictures from *Totally Rad Actions*. It comes preloaded with some really great textures,

and is a fabulous interface for applying and changing textures. The cool thing about Dirty Pictures is that you can see what your image will look like with different textures applied— all within the dashboard and without wasting a ton of time. I love Dirty Pictures, and even though I only occasionally add a texture or overlay to my photographs, I always use the Dirty Pictures interface when I do.

TEXTURES

ABOVE If you like to apply textures, Dirty Pictures (by *Totally Rad Actions*) provides you with an incredible interface and some interesting textures as well.

Black and White

I truly believe that black-and-white images are completely subjective. Personally, I like black-and-white images that don't have blocked-up shadows; rather, I like to see shadow detail instead of straight black. I also like a flatter, warmer image with a touch of grain, and I have worked hard to create and to find actions and presets that will help me achieve the black-and-white look that I want.

My workflow consists of a combination of Adobe Lightroom and Adobe Photoshop. Most of my work is going to occur in Adobe Lightroom—in fact, many of my images will be processed in Lightroom and nothing else. Keep in mind that I deliver high—anything from 750 to 1250 images per wedding and 100 to 250 per portrait session, and I'm only fine-tuning a handful of those in Photoshop. I want to do most of my work in Lightroom and only finesse the images that I really love in Photoshop.

My first step is to import the photographs into Lightroom. I have three black-and-white presets that I have developed (one of the great things about Lightroom is the fact that it is incredibly easy to develop presets that give your Raw photos the "look" that you like). All three of the presets create a black and white with less muddy skin tones, but still a fairly flat black and white that I don't want to lose all of that shadow detail by adding a lot of black or contrast. The great thing about Lightroom is that you can mix your black and white to taste in the Grayscale Mix section of the Develop module—I like my skin tones to be a bit creamier, so I lighten my red and yellow tones (because the skin is made up of red and yellow) while darkening my blues. My Lightroom black-and-white presets will give me a file that I am happy to show the client,

but one that can be improved upon once I take the file into Photoshop.

Now for the Photoshop bit—I like to create my own actions and play around in Photoshop, but when it comes to black and whites I go with one of the masters. I have to admit, I'm a Photoshop action junkie. I've tried almost everything out there because I love and adore Photoshop and I get a kick out of trying new actions. I discard most of them, but occasionally I will find something that I really like, and I love some of the black-and-white actions created by Jeff Ascough. They are customizable and they add a little punch to my black-and-white image straight from Lightroom. (Now would be an important time to mention that any action will give you a bad result if your file isn't properly exposed—garbage in, garbage out.)

Finally, I occasionally run a specialty action to "season" my black-and-white images. I like them to be a bit grainier, with a subtle vignette and blurred edges. I also like a touch of a warm tone, and a more subtle contrast shift. There are two actions that I really like when it comes to seasoning my black-and-white images, and both of them come from the *Totally Rad Action* set (one from the original, the second from the remix set). The thing I love about these actions is that they are completely customizable. So many action sets out there flatten your images or make the adjustments to the background layer, leaving you unable to tweak them. The TRA set is different—the layers are left open, letting you play with the opacity of each layer to come up with a look that is your own. My favorite is the Old Skool Action (the set has several)—I run it and then lower the opacity to anywhere from 20 to 40 percent, but usually closer to the lower end. (Keep in mind

ACTIONS

ABOVE One of my favorite black-and-white actions from Jeff Ascough allows you to add contrast in a second layer.

LEFT Old Skool, by *Totally Rad Actions*, is one of my favorite finishing actions for black-and-white images. I add it to images that have already been converted to black and white and lower the opacity to 20 percent.

that I am starting with an image that has already been adjusted with a Jeff Ascough black-and-white action.) This gives my images just a touch of grain, vignette and tone. The second action that I use to season my black-and-white images (used less frequently) is the Homestead black and white. Once again, I change the tone and compression layers and then lower the opacity on the overall effect. For me, it is important to add just a touch of these actions. I don't want my images to

scream "TOTALLY RAD OLD SKOOL ACTION" or any action at all; rather, I want the effect to be more subtle than that.

The great thing about Lightroom and Photoshop is that my black and white may not be your black and white. Just as you can choose your favorite black-and-white film, there is no need to be limited by one set way of converting a black and white in the digital age. These two programs will give you endless options for coming up with your own look.

OUTPUT

Once you finish processing your images, you will need to share them with the world. Some couples showcase their images across several different web platforms. Others simply burn a DVD of all of the images and hand them over to the couple. From Velasquez to Norman Rockwell, the use of light, coupled with the deliberate composition that you find in paintings, can provide a great deal of inspiration for any artist.

You can also look for brilliance in movies, ad campaigns, sculpture—there are so many sources that can stimulate your creativity. If you want actual wedding-related inspiration, though, there are fewer places you can turn.

RIGHT To capture the detail of the back of the bride's dress, it is always advisable to engineer a shot where the couple walks away from you, preferably with a stunning backdrop too.

Blogs

Blogs have become essential in the wedding-photography world. More couples are finding their photographer on the internet, and blogs are important because they showcase your recent work as well as help you with search-engine optimization. Of course, brides and grooms love showing off their "sneak peak" on the blog shortly after their wedding, and I love using my blog to showcase some of my favorite images from recent weddings while driving traffic to my blog. I work on a Wordpress platform, and there are many different blog templates available (many of which are customizable so that you can brand your blog). I use the ProPhoto Blog Template, which was designed specifically for photographers and offers hundreds of different ways to tweak your blog to suit your style. Many designers also offer custom blogs (many of which are built on the Wordpress platform) including Luxecetera and Flosites. Into The Darkroom is a design company specializing in websites and blogs for photographers, and they offer several different matching website/blog templates. There are also several different websites that offer blog integration—my website is a customized Clickbooq website with an integrated blog section (Wordpress with the ProPhoto skin).

When posting images from a recent wedding, I try to incorporate as many of their details as I can. I want to give viewers the sense of what it felt like to be at the wedding—the decorations, the food, the entertainment, the ambience, etc. I also include some of my favorite shots of the bride and groom and I try to highlight my style to give potential clients an idea of what it might feel like to work with me. I have

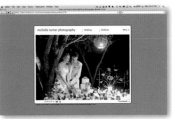

CLICKBOOQ

ABOVE Several years ago, I chose *Clickbooq* for my website because of the ease of customization and the fabulous customer service. As my branding has evolved, I have been able to tweak the site to my heart's content.

INTO THE DARKROOM

OPPOSITE Although it is not my primary website, I have a few sites that use *Into The Darkroom* templates. They are easy to customize and offer a beautiful non-flash version for surfing on mobile devices.

chosen to present my blog images in composite form. It is essentially one large image with 20 to 30 photographs laid out magazine-style in the print. The images are different sizes, and verticals are mixed with horizontals. I have created a series of actions to create custom composites.

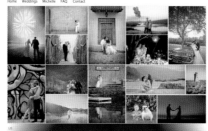

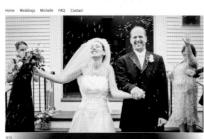

Online Proofing and Ordering

Many photographers have chosen the convenience of online proofing and ordering over paper proofs and proof catalogs, and the number of online proofing options has exploded in the past five years. Online proofing and ordering solutions run the whole gamut—from full services that handle everything (from hosting your images online to the order fulfillment itself) to online shopping carts over which you have complete control every step of the way. You will pay a service fee and a percentage of your profits to the former while you will have to bear the brunt of the work with the latter, so choose a solution that works best for you.

All-in-one proofing solutions are offered by *Pictage*, *SmugMug* and *Zenfolio*. Each has a different price point and a different level of service. Be sure to research reviews and the quality control of each before committing to a solution, especially since you will no longer be a part of the ordering process and the lab will communicate with and ship directly to your customer. In some cases these services will allow you to test-drive their shopping carts for a short period, and this will give you a chance to check out the interface and compare each to the other. All three allow

REDCART

ABOVE I love *RedCart*—the shopping cart is customizable and my clients have no trouble with the interface.

you to brand your shopping cart link with your logo and to decide which products and services you want to offer your customers.

At this point, I prefer to take and prep the orders from my clients myself. My shopping cart is from *RedCart*, and I have found the customer service to be fabulous and the cart itself to be easy for my customers to use. I use *ProDPI* (my lab) for my order fulfillment, and *RedCart* has a tool that helps me prep my orders (sizing and cropping) for the lab. I have been a *ProDPI* client for years, so I feel completely comfortable allowing them to drop-ship the order directly to my clients. There are also solutions from *PickPic* and *Into The Darkroom* which will allow you to do the same thing. Once again, each is at a different price point and gives you a slightly different design and interface. Look at several sites from each before committing to a solution.

DVD Proofing

EMOTION MEDIA

ABOVE *Emotion Media* offers several different slideshow and DVD proofing options that are competitively priced for subscribers.

Although I offer online proofing and ordering to the guests of the couple, I recently started DVD proofing for the families of my couples. There are several different programs that you can use to create a DVD that will allow you to click through the images on your television without the need for a fast internet connection. I use a DVD proofing service (from *Emotion Media*) to create the audio and video files for me. This proofing method is as simple as uploading the photographs to *Emotion Media* and downloading the DVD files a few hours later.

I like offering DVD proofing because it provides another level of customer service. It also allows me to present a very simple solution to my clients who want to view the photographs on a big screen, in a group, or with a quick scroll-through feature. Because *Emotion Media* offers a subscription service, I don't have to pay a high per-DVD fee for this service.

Hard-Copy Proofing

Some of my clients still prefer to see their images in print. I understand this point of view because I prefer to view and evaluate photographs of my own family in print rather than on a computer screen. I appreciate the tactile experience that prints give me, and I know that I am seeing the true color of the images (since computer screens that are not calibrated can destroy the viewing experience of even the best photographs due to incorrect color and density).

I offer two types of hard-copy proofing. The first is a custom box of actual proofs—there are several companies that create custom image boxes, including *Finao*, *Seldex* and *WHCC*, and while I have chosen to work with Finao because of their beautiful printing and their excellent customer service, I have seen a number of beautiful boxes from several different labs. I fill the box with 4x6" proofs—these are bordered and sharpened (usually a simple black keyline on a white background

and sharpened with Kevin Kubota's Magic Sharp). If I am presenting proofs to my portrait clients then I may choose a more elaborate border—*Itty Bitty Actions*, *Design Aglow* and *Life Art at Home* all have some gorgeous borders that can be applied to images.

The second option is a proof catalog. For portrait sessions my clients receive spiral-bound photographic prints with numbered thumbnails of each of the images. If I know that my clients are considering fine-art prints, I may upgrade a few of their thumbnail pages and print them on some of the fine-art papers that I offer. This system works well for my portrait clients (or for engagement sessions), but I deliver anywhere from 700 to 1200 images per wedding (and even more for multi-shooter weddings), so I found the spiral proof book to be impractical. Instead, I create my proof volume through a book company which binds the proof sheets (with nine thumbnails per page) together in one volume.

Slideshows

Slideshows are a fantastic way to showcase some of your favorite images from a wedding. Viewing an online gallery can be an overwhelming experience, and sometimes couples just want to share the highlights of their day with their family or friends. There are many different slideshow options. Personally, I use iMovie to create a slideshow and then export it at the right size for *YouTube*. I like using *YouTube* because it is viewable on a number of mobile devices that block many of the flash-based slideshows that are available. *YouTube* also offers searchable videos, so it will give you an boost in search engine optimization if you use it right.

While *YouTube* is great, there are many other options out there. Some of them offer a beautiful interface, large images, and one-step slideshow and publishing. Showit is a flash-based program that creates beautiful shows and gives you the ability to brand the slideshows with your colors, logo and more. *Into The Darkroom* also carries a slideshow program that generates fantastic slideshows with large, web-optimized images.

HARD-COPY PROOFING

OPPOSITE Borders can be added to proofs before presenting them to the client.

YOUTUBE

BELOW Slideshows are a great way of showing images to other people. *YouTube* is particularly good because it is viewable across a variety of mobile devices.

Social Media

Social-media sites such as *Facebook* and *Twitter* are other avenues for sharing your work with your clients and with the world. Although you have to be careful with social media due to the usage rights of *Facebook* and others (make sure to read through the fine print regarding image sharing through any website), it is a great way to touch base with current and future clients as well as their guests and even the friends of guests. I like to upload a few favorites from every wedding on *Facebook* (with my logo on them, of course) and I will tag my clients if they want me to do so.

That way I can be sure that they are uploading them at the best size for *Facebook* (rather than letting *Facebook* resize the images for them) and that the images are properly identified and traceable.

While I sometimes use *Facebook* to drive traffic to my blog, I use *Twitter* for this purpose much more. I have set up my *Wordpress* blog to autopublish my blog headings to my *Twitter* account so that my followers can see in their *Twitter* account when I publish a new post to my blog.

BELOW Another fantastic way of sharing your wedding images is on social-media sites.

Printing Solutions

I print the majority of my images through my pro lab—I evaluated several labs and fell in love with the prints, consistency and customer service from *ProDPI*, so I use them for all of the printing that I do on photographic papers. I also use *ProDPI* for all of my press-printed needs (with the exception of my business cards, which are printed through *MOO*). Before you choose a lab, be sure to order some test prints to make sure that you like their printing as well as the papers that they offer.

When I want to print my images on fine-art papers, I use a large-format Epson printer. I have two of these in the studio and I stock a variety of fine-art papers in my office, although I am partial to Moab Entrada Rag Natural 300 and Epson Velvet Fine Art paper. Both are heavyweight fine-art papers that allow for excellent and vivid color rendition, and each has a surface texture that contributes to the fine-art look (and feel) of the images. If I need the images printed on a different type of paper or I need a specialty size, I like to outsource my fine-art images to *Simply Color Lab*.

LEFT *ProDPI* offers a whole range of wonderful press printed and photographic products. Their customer service is phenomenal, too.

BELOW Inkjet printers are capable of producing very high-quality prints on a variety of paper formats and types. A good option includes the Canon PIXMA iP1900 and the Epson Stylus P50.

Specialty Products

Custom Photo Box: There are quite a few specialty products that I use and love. One of them, the custom photo box, was mentioned in the proofing section. I also use the image box (albeit a different size) to present a series of unframed matted (or mounted) images to the client. Most of the time the client will display the box and swap out the matted print on an easel on a regular basis. It is a lovely way to display unframed prints. I purchase my photo boxes from *Finao* because I love their printing and customer service.

Cards: Many of my clients like to send holiday images, save-the-date cards, or even thank you cards with images from their weddings. We offer our clients beautiful designs and incredible press-prints on linen or watercolor papers.

Framed Prints and Gallery-Wrapped Canvases: There are so many beautiful frames that are available in so many different sizes, colors and styles. It is possible to match a frame not only to the photograph itself, but also to the decor of the room. When a client orders a framed print, we discuss colors and trim options, as well as the room in which it will hang. It is important to understand whether a room is formal or informal, whether it's a child's colorful room or a neutrally colored living area, before you frame the image. I order most of my frames through *Wild Sorbet*, although I also work with a framer for my standard black frames that I use for my fine-art collection.

Gallery-wrapped canvases are my favorite products and they adorn the walls of my studio/office as well as the walls of my home. I enjoy the texture of the print and the way the image wraps around the frame, and I think a canvas lends itself to a fabulous presentation. I order all of my canvas prints through *Simply Canvas*, although many labs also offer canvas prints as well.

I offer a dozen wall inspiration-boards (predesigned frame or canvas clusters) to my wedding and portrait clients. Sometimes it is difficult for clients to envision their images on their walls (especially in a series) and these templates help me show them what is possible before we order an expensive cluster. There are several templates out there (*Design Aglow* offers a very good one), but I love the templates available from *Rock the Walls* (and *Life Art at Home*). They also have a series of templates that are compatible with ProSelect, so if you use that fabulous selling tool in your studio you can drag and drop the client's images right into the templates.

Photo Jewelry: This is not a product that I sell very often, and most of the time these products are sold after family or baby portrait sessions. However, I do occasionally sell a heavy sterling keychain or ornament to the parents of the bride and groom. I use *Kimbra* for all of my photo jewelry.

ABOVE A modified inspiration template from *Life Art At Home* (lifeartathome.com).

TOP The gallery-wrapped canvas is one of my favorite products. Just be sure to choose an image that leaves room for wrapping around the edges of the frame.

ABOVE The standout is a product that is becoming a favorite with my clients. *ProDPI* produces beautiful standouts.

Design

I am not a designer. At least, I am not good at coming up with complex designs for my products. I love creating wedding albums because I prefer a clean, uncluttered design to let the images shine (I will discuss that in the section on albums), but when it comes to photo cards, fine-art-border designs, or children's albums I prefer to use a pre-designed template that I can tweak. There are several designers who cater to photographers, and they run the whole gamut from simple, static templates to complex, customizable templates. My favorite source for downloadable designs is *Design Aglow*. Not only is the *Design Aglow*

blog a fabulous source of inspiration, but it is also a source for anything from posing guides (I've had images featured in the last few wedding posing-guides from *Design Aglow*) to photo-card templates.

I also like some of the designs from *Luxecetera*. Although I think of them first and foremost as an identity/brand design firm, they also create some beautiful cards and marketing pieces for professional photographers. There are several other individual designers and design groups—a simple google search will unearth a number of them, and you can sift through them to find one which sells products in a style that matches your own.

TEMPLATES

ABOVE, LEFT AND BELOW Although I rarely use templates for my bride and groom albums, I do like to use them for engagement and boudoir albums. This particular album template comes from The Shoppe Designs (theshoppedesigns.com).

Albums

As I mentioned in the design section, I favor clean, uncluttered album designs. I offer two basic styles—coffee-table album (thicker pages, fewer pages, more like an album) and a magazine album (thinner pages, more pages, more like an art book that you might purchase in a bookstore). With the latter, I generally design albums with several images per page, with an occasional small color bar to enhance the photographs and tie the design together. With the former, I prefer to have one image per page (like an art book) with a full-bleed opposite a smaller photograph on the other side. I use *Finao* for my coffee-table albums and *Iris* for my magazine albums. The quality of the books from both companies is excellent and the customer service is quick and attentive.

The one-image-per-page albums are simple enough to design—I simply drag, drop, and resize my images onto the pages in Photoshop. However, the multiple-image albums present a more complicated set of design needs. I do not use templates for my wedding albums, and I want to produce a clean, simple, unique design as quickly as I can. For that, I use Fundy Album Builder. The program allows me to fly through my album design by using a combination of Adobe Bridge and the Album Builder dashboard within Photoshop. With just a few clicks I can swap photos, resize them and edit them in Photoshop.

BELOW The Album Builder dashboard from FundySOS, my favorite album-layout program.

TOP Another album spread produced with Album Builder in Photoshop.

ABOVE This is an open spread in Photoshop with the Album Builder dashboard. Album Builder makes it incredibly easy to create clean, uncluttered layouts in a matter of minutes.

Publication

LEFT The *Cake and Pictures Pantry* is a relatively new blog, but it showcases beautiful images from photographers around the world. The *Cake and Pictures Pantry* and *Style Me Pretty* are two of my favorite wedding blogs.

OPPOSITE This image has been published on a few different occasions. The balanced composition, the reflection, and the inclusion of the sign (which gives a sense of place to the image) all add to its marketability.

There are people who argue that the age of the magazine has disappeared, but I have to admit that I am holding out the hope that they are wrong. I absolutely love to see my work in print in a magazine, and I also love when my weddings are featured on some of the amazing design blogs that are out there. I have a few editors that ask for weddings now, but I arrived at this point by submitting, submitting, and submitting again. If you would like to have your images published or your weddings featured, you will need to follow some simple rules:

Pay attention to the details: Magazine and design blogs love detail photographs. Make sure you photograph the details from a variety of angles in both horizontal and vertical formats. Use several different lenses and change your perspective. I like to photograph most of my detail shots with a 35mm lens or my 60mm macro.

Photograph the venue: Get a few great shots that showcase the interior and the exterior of the venue, whether during the day or at night (or preferably both). I love to photograph venues with my 24mm lens because it doesn't require that I walk a mile away to get the shot.

Look to current publications for inspiration: The best way to have your wedding featured is to know what the publication or design blog of your choice is looking for. Different magazines and blogs have different styles, and anything from the type of wedding you photographed to how you process your images during the post-processing stage can play a role in determining whether your wedding will be picked up or not.

Consider joining an editorial service: *Two Bright Lights* is a fabulous online service which allows you to share your images with vendors and to submit them for publication. If your wedding doesn't get picked up, submitting the images to a second blog is as easy as clicking your mouse.

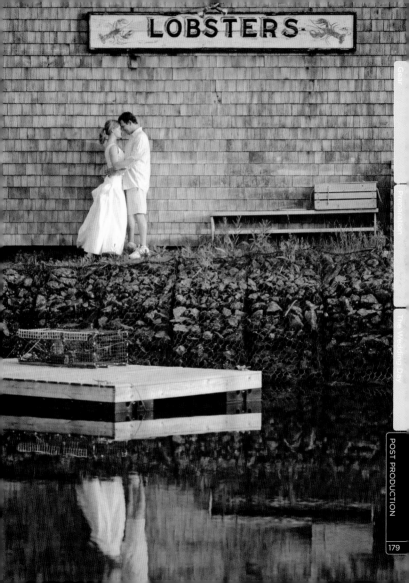

KEEPING IT FRESH

Perhaps you want to take your wedding photography to the next level, or maybe you just need some inspiration for an upcoming wedding. As artists, our style should change and develop as we change and develop. So, how do you keep it fresh? I would definitely suggest looking for inspiration in other mediums. David Williams, a photographer from Australia who I really respect, teaches a great course on improving your craft by studying other mediums.

From Velasquez to Norman Rockwell, the use of light, coupled with the deliberate composition that you find in paintings, can provide a great deal of inspiration for any artist. You can also look for brilliance in movies, ad campaigns, sculpture—there are so many sources that can stimulate your creativity.

RIGHT Chest to chest, this couple has been captured in this magical and colorful setting.

Networking/Model Shoots

It is a great idea to begin networking with other photographers in your area. Chances are that you can find another wedding photographer who inspires you in some way, or perhaps simply seeing how someone else does things will inspire you to try some different things yourself. It's wonderful to be a part of a regional group of photographers—people who you can see face-to-face and get together with for model shoots or round-table discussions or brainstorming sessions.

I belong to several different communities, but one of the groups that gives me the most feedback and asks me to push myself harder than any other is a group called ShootStyle. The six of us get together to teach other photographers, and in the process we always end up learning something new ourselves. Whether we each present a method for lighting receptions (and each have a different system) or a method for posing (or unposing, as the case may be), it can be a wonderful learning opportunity to hear how five other people do something. We have also started an online resource chock-full of how-to articles and wedding inspiration.

To keep things fresh, our group also sets up a series of model shoots and we push ourselves by photographing in different locations, under different conditions, and in different lighting situations. And of course, we always have a fabulous time at all of the ShootStyle get-togethers!

OPPOSITE During one of our ShootStyle model shoots, we worked with a dressmaker. It was a win-win situation since she wanted photographs of her creations and we wanted very different dresses for our models.

Inspiration

You might feel like you need image inspiration rather than technique inspiration. If this is the case, then you may want to follow some of the blogs of your favorite wedding photographers or some of the wedding-design blogs (*Style Me Pretty* and the *Cake and Pictures Pantry* are two good examples). If you immerse yourself in wedding imagery, chances are that you will come up with great ideas for things that you want to try or poses that you might want to tweak.

If you feel in the need of inspiration while you are in the middle of the wedding, you might consider a posing guide. There are several different guides available, but you can check *Design Aglow* for a few themed guides. If I have a great idea that I want to remember,

4X6″ WEDDING-PARTY POSING

ABOVE Posing guides can be a great way to jumpstart your creativity on or before a wedding day. You can print them or load them onto your iPhone and refer to them on the fly. This is the Wedding Party series from *Design Aglow*—it is a fabulous resource for cool wedding-party shots. They also have a Bride and Groom guide (and some other portrait guides). I have several images in the guides, but I still get several new ideas every time I look at these cards.

I will sometimes sketch myself a picture, leave myself a note, or grab one of my photos to jog my memory and load them onto my iPhone (or iPod or any other mobile phone or device capable of scrolling through photographs). Sometimes a visual cue is all you need to get started.

Online Communities

Online communities are another great resource and they offer photographers a great way to connect with other photographers. There are communities that specialize in a certain type of photography (for example, the *Digital Wedding Forum* caters to professional wedding photographers, although it now has sections for portrait and boudoir photographers), and communities that specialize in certain types of photographers (*Clickin' Moms*, for example, caters to the mom with a camera), and forums that are open to all photographers and all types of photography (*I Love Photography* and *Open Source Photo* are examples).

Many of these forums have inspiration threads, where the members post their best

TOP *Open Source Photo* is a popular forum for photographers.

ABOVE *Clickin' Moms* is geared primarily towards moms with an interest in photography, and it is a happy and supportive forum.

shots and inspire other members. These forums are also great places to ask tough questions, such as "How do I deal with a 34-person wedding party?" or "What is the best program for creating a bootable copy of my Mac?" Forums are also a great place to get some honest vendor reviews, swap funny photography-related stories, or even vent about something in your business that is bothering you.

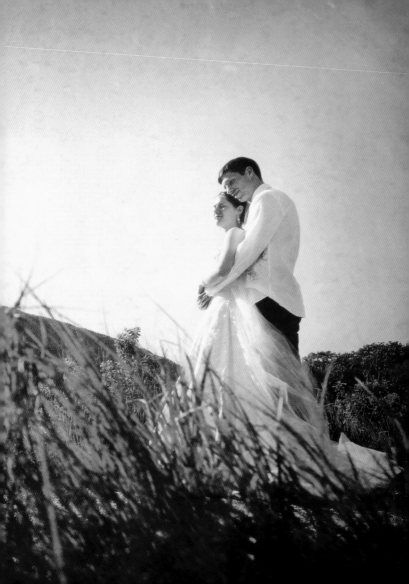

Glossary

APERTURE

The opening behind the camera lens through which light passes on its way to the image sensor (CCD/CMOS).

ARCHIVE

The process of organizing and saving digital images (or other files) for ready retrieval and research.

BACKLIGHTING

The result of shooting with a light source, natural or artificial, behind the subject to create a silhouette or rim-lighting effect.

BIT DEPTH

A pixel with 8 bits per color gives a 24-bit per pixel image; the more bit depth, the more colors can be digitally represented.

BYTE

A group of 8 bits; a basic unit of digital information.

CALIBRATION

The process of adjusting a device, such as a monitor, so that it works consistently with others, such as scanners or printers.

CCD

(Charge-Coupled Device). A light-sensitive imaging chip used in digital cameras. This chip sits in place of the film of a traditional camera.

CF

(Compact Flash) Card. The most common of several types of memory cards that are used in digital cameras. The CF "Type 2" slot can also take a small hard disk (see Microdrive).

CMOS

(Complementary Metal Oxide Semiconductor). A light-sensitive imaging chip used in digital cameras. It is cheaper to manufacture than the CCD chip, but the results are virtually indistinguishable.

CMYK (CYAN, MAGENTA, YELLOW, KEY)

The four process colors used for printing, including black (key).

COLOR GAMUT

The range of color that can be produced by an output device, such as a printer, a monitor, or a film recorder.

COMPRESSION

The series of algorithms applied to a digital image to reduce its file size without sacrificing quality, at least to a point. JPEG images are compressed, whereas TIFF is a 'pure' format.

CONTRAST

The range of tones across an image, from bright highlights to dark shadows.

CROPPING

The process of removing unwanted areas of an image, leaving behind the most significant elements.

DEPTH OF FIELD

The distance in front of and behind the point of focus in a photograph, in which the scene remains in acceptable sharp focus.

DPI

The measurement of resolution by Dots Per Inch.

FILL FLASH

The use of a camera flash in daylight to fill in shadows.

FIRMWARE

Computer instructions that are stored in a read-only memory unit rather than being implemented through software, typically camera-control software.

FOCAL LENGTH

The distance between the optical center of a lens and its point of focus when the lens is focused on infinity.

FOCAL RANGE

The range over which a camera or lens is able to focus on a subject (e.g., 0.5m to Infinity).

FOCUS

The optical state where the light rays converge on the film or sensor to produce the sharpest possible image.

F-STOP

The calibration of the aperture size of a photographic lens.

FTP

(File Transfer Protocol). An extremely simple and useful way of transferring large files from one computer to another.

ISO

As with ASA on a film camera, a measure of light sensitivity. You can often adjust this just as you would switch films.

JPEG

The now-standard file format for digital images on the Web. JPEG, also known as JFIF, takes areas of 8 x 8 pixels and compresses the information to its lowest common value. Created by the Joint Photographic Experts Group.

MEGAPIXEL

The standard unit of measuring image size in digital cameras. One 'megapixel' is one million pixels.

NOISE

The random pattern of small unwanted spots in a digital image that are caused by stray electrical signals.

PHOTOSHOP

A powerful software program from Adobe Systems used to manipulate images. Pictures can be dramatically changed using Photoshop: colors can be altered, images sharpened, parts of the picture removed or moved.

PHOTOSHOP ELEMENTS

A consumer version of Photoshop with fewer features, but is still very useful for manipulating images.

PIXEL

Derived from the term "Picture Element," the smallest unit of a digitized image. Each square dot that makes up a bitmapped image carries a specific tone and color value.

PPI

Pixels Per Inch. A measure of the resolution of a bitmapped image. (See also DPI and Bit depth.)

RAM

(Random Access Memory) The working memory of a computer, to which the CPU or central processing unit of the computer has direct access.

RAW

A file format created by most high-end (DSLR) cameras, containing all the pixel information with no compression. Each camera manufacturer has its own version of Raw. For Nikon, it is the Nikon Electron Format NEF.

RESOLUTION

The amount of detail shown in an image, whether on screen or printed. Resolution is measured in dots per inch (dpi) in print or pixels per inch (ppi) on screen.

RGB

(Red, Green, Blue). The three primary colors of light, and the system used by computer monitors to display images.

ROM

(Read Only Memory): Any memory disk or media that can only be read, not written to. ROM retains its contents without power. Most CDs, once burned with data or images, become read-only (i.e. CD-Rom).

SD

(Secure Digital) Card. A postage-stamp-sized flash memory card that has a locking switch that can prevent accidental erasure of data once engaged.

SATURATION

The purity of a color, going from the lightest tint to the deepest, most saturated tone.

SELECTION

In image editing, a part of an on-screen image that is chosen and defined by a border in preparation for manipulation or movement.

SHUTTER SPEED

The time the shutter (or electronic switch) leaves the sensor or film open to light during an exposure.

THUMBNAIL

A miniature representation of a larger image file for onscreen viewing or printed contact sheets.

TIFF

(Tagged Image File Format). A cross-platform image file format for bitmapped images that has become a standard for high-resolution digital photographic images that are going to be printed. Some RAW formats are essentially TIFFs.

USB

(Universal Serial Bus). A standard port on most modern computers for the connection of external devices from keyboards to memory card readers.

WHITE BALANCE

A camera control used to balance exposure and color settings to correct any color cast that may not be visible to the human eye.

WIFI

From "Wireless fidelity," used generically when referring to any type of 802.11 network, whether 802.11b, 802.11a, Airport, and so on.

ZIP

A method for compressing files on a computer for storing and transmitting them at a reduced size.

ZOOM LENS

A camera lens with an adjustable focal length which gives, in effect, a range of lenses in one. Drawbacks compared to a prime lens include a smaller maximum aperture and increased distortion.

Index